Ladies Drawing Night

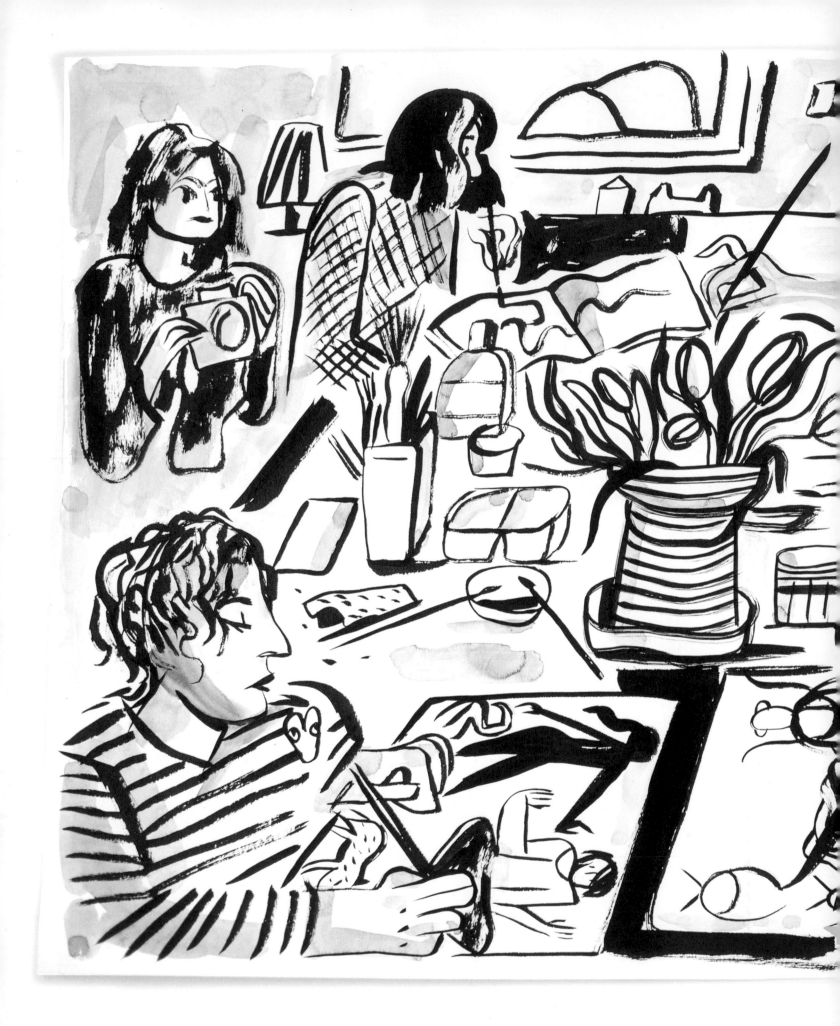

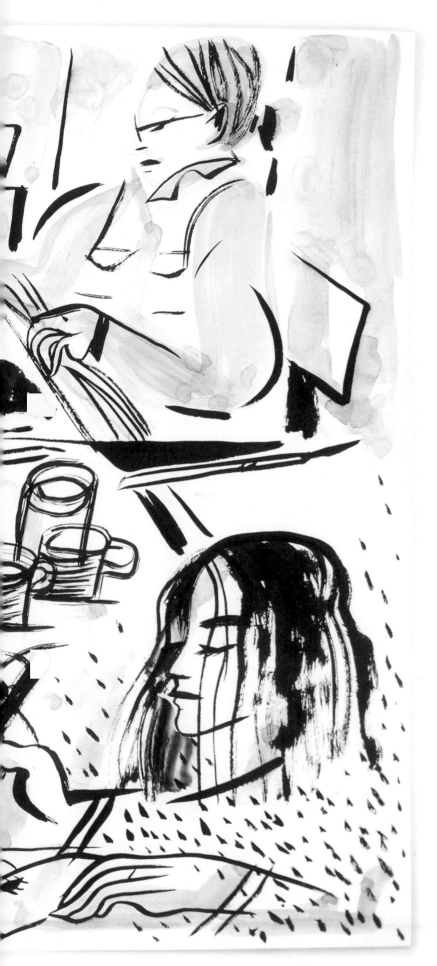

Ping Zhu

Ladies Drawing Night

Make Art, Get Inspired, Join the Party

by Julia Rothman,
Leah Goren,
and Rachael Cole

photographs by

Kate Edwards

CHRONICLE BOOKS

SAN FRANCISCO

Library of Congress Cataloging-in-Publication Data:

Names: Rothman, Julia, author. | Goren, Leah, author. | Cole, Rachael, author.
Title: Ladies drawing night / By Julia Rothman, Leah Goren, and Rachael Cole.
Description: San Francisco : Chronicle Books, 2016.
Identifiers: LCCN 2015037470 | ISBN 9781452147000
Subjects: LCSH: Drawing—Study and teaching. | Women—Societies and clubs.
Classification: LCC NC593 .R68 2016 | DDC 741.07—dc 3 LC record available at
http://lccn.loc.gov/2015037470

Manufactured in China.

Designed by ALSO

10 9 8 7 6 5 4 3 2 1

Chronicle Books LLC
680 Second Street
San Francisco, California 94107
www.chroniclebooks.com

Chronicle books and gifts are available at special quantity discounts to corporations, professional associations, literacy programs, and other organizations. For details and discount information, please contact our corporate/premiums department at corporatesales@chroniclebooks.com or at 1-800-759-0190.

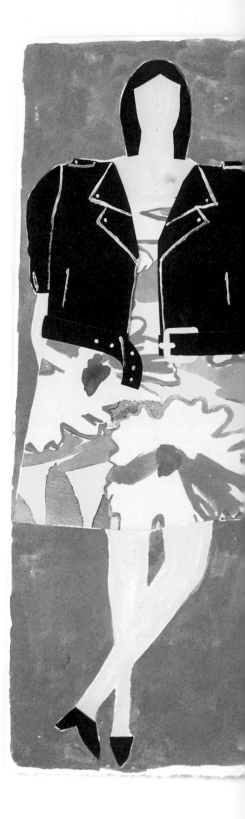

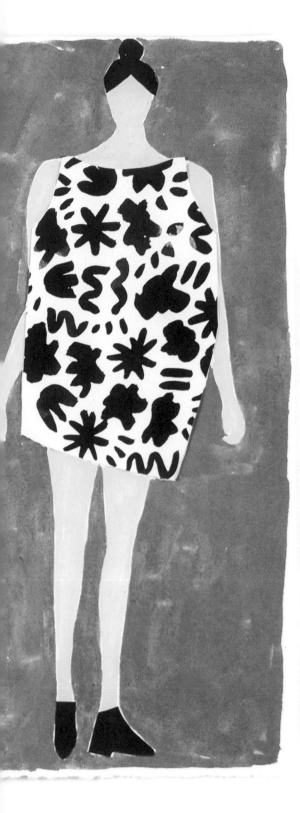
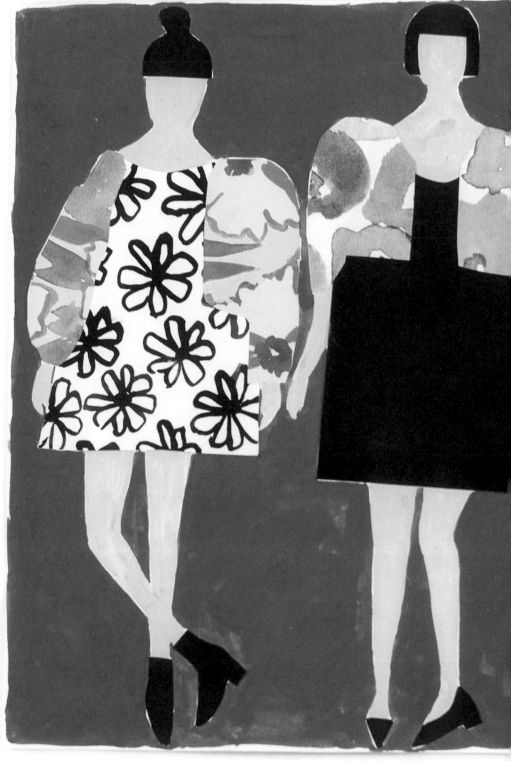

Leah Goren

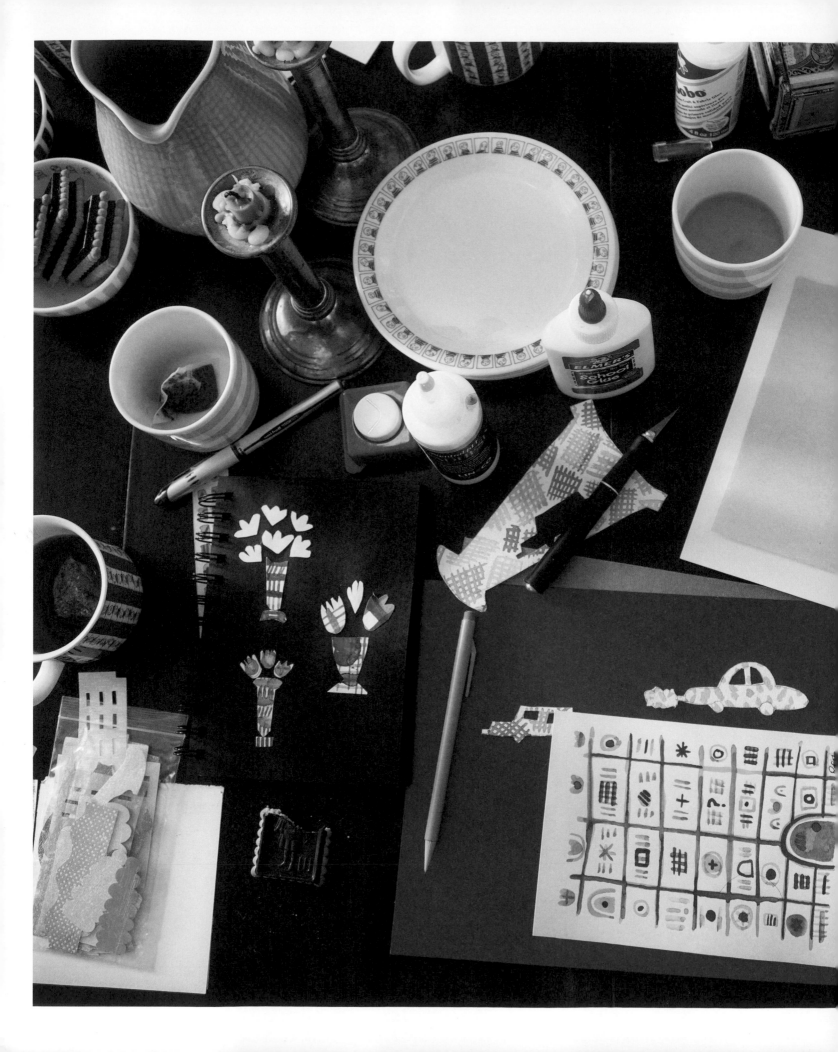

Contents

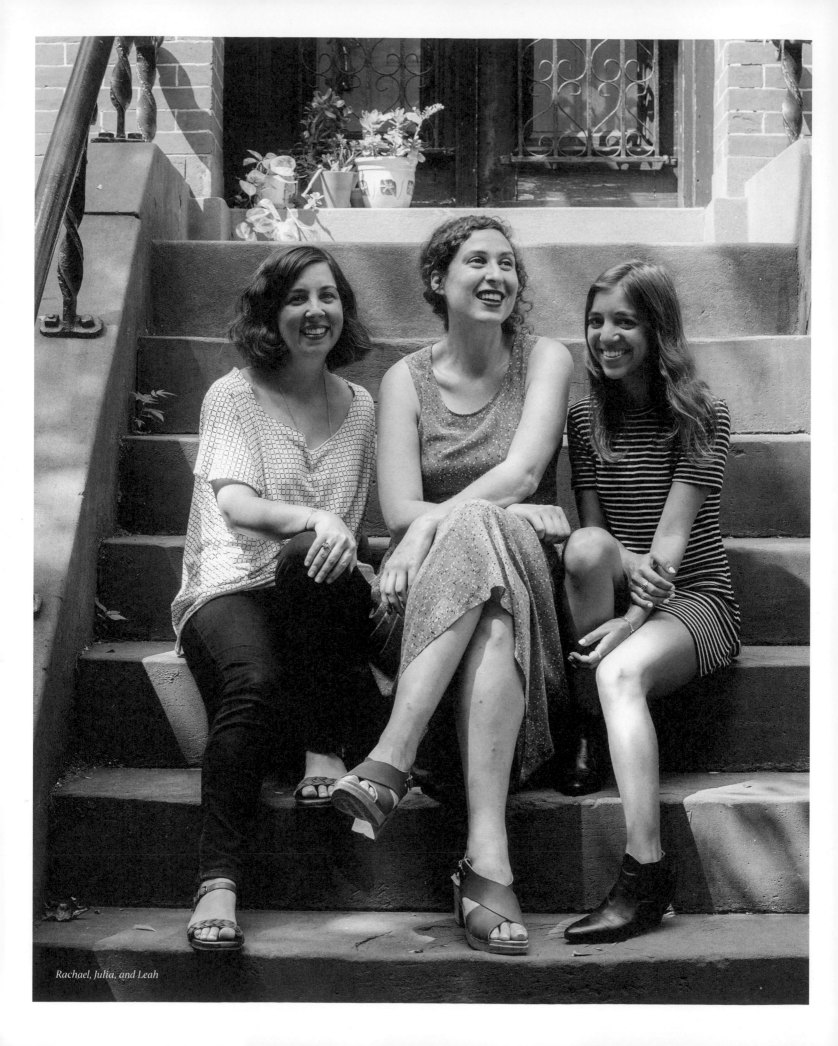

Rachael, Julia, and Leah

"Ladies Drawing Night" is not the most imaginative title, nor do the words capture the amount of incredible inspiration and creativity we have felt at these weekly gatherings. Yet, this is what stuck when the three of us—Julia Rothman, Leah Goren, and Rachael Cole—first started getting together four years ago to draw.

There is nearly a decade in age between each of us. Rachael is a mother and seasoned children's book art director. She graduated from the School of Visual Arts' MFA illustration program. She is the author of an upcoming picture book inspired by her evening moon-hunting walks with her son, and she works on personal illustration projects whenever she can. Julia, a Rhode Island School of Design graduate, has done illustration for a variety of editorial clients as well as patterns for dishware, wallpaper, and stationery companies. She authors and illustrates her own books and organizes collaborative book projects. Leah, the youngest among us, works continually on freelance illustration projects and also designs her own clothing, accessories, and ceramics, which she sells from her web shop. Despite our age differences, our interests aligned.

Julia met Leah when she came as a guest speaker to one of Leah's illustration classes at Parsons School of Design. Rachael and Julia connected at an illustration conference. When Julia had the idea for a collaborative scarf project, she brought the three of us together. Our scarf series was a success, and we vowed to continue with collaborative projects as a group. But most of all we really enjoyed the initial drawing process and each other's company. We decided to continue to meet at Rachael's house in Brooklyn, thinking we would eventually embark on something again. Instead we relished in just drawing together and continued to do so without any next plan—and Ladies Drawing Night was born.

Meeting in the evening with brushes, paint, and paper is a break from client work. All day we design, illustrate, and draw to pay the rent. These evenings together are our free time, where we can make whatever we want without an editor or art director giving direction and feedback. We use these nights to experiment with different media: thicker brushes, nib pens, collage. We draw whatever we want: animals, fashion models, trains. It is relaxing and puts the fun back into an activity that has become a job. Plus, we talk. We discuss work—both our opportunities and our challenges—and what is happening in our personal lives. We became close. We support each other through stressful situations and often get up out of our seats to give a hug to someone having a bad day. Other times, we are so engrossed in drawing that we can go for periods working in complete silence. The evenings are a kind of group therapy. We supply ourselves with plenty of wine and chocolate-based snacks to keep us going. Sometimes we invite other friends to join in.

Our male friends often complain. "Why is this only for ladies? That's gender-biased!" It's true, it is. It's not that we feel that our guy friends wouldn't get it, it just feels right with all women. It is one less divide among us, a source of common ground. Once in a while one of our boyfriends joins in, or Mars, Rachael's husband, tries painting, but "ladies only" is a general rule we keep (even when guys jokingly offer to wear wigs or dresses). For us, there is limited time with just women. We really enjoy it, so we stick to it.

Sometimes we hate the drawings that we make. Other times the art that amasses from the evening is impressive. We always pick our favorites and post them online to share. We hashtag the evening with #ladiesdrawingnight to collect all of our images from these nights. There has been a lot of positive response, not only to the artwork itself, but also to the idea of organized drawing sessions and shared creativity among women. Strangers started tagging their friends and commenting "we should do this" or "I wish I could come." We realized that this ritual was something that really resonated with people of all ages, amateur artists to professionals. That's why we decided to adapt it into a book: to share the custom.

This book is an archive of ten Ladies Drawing Nights. We decided to provide a prompt that would loosely theme the evenings, and we invited talented guests who seemed experienced in the topic. This way we could learn something from them—a technique, a quick tip—or just hear about their experience working in the field of art and illustration. Many of these women are well-known, award-winning illustrators, while others are just starting to advance in their careers. Being in New York City, and especially in Brooklyn, has afforded us the opportunity to meet so many other creatives. There is a strong community buzzing with relentless energy. Everyone seems eager to connect, collaborate, or just hang out

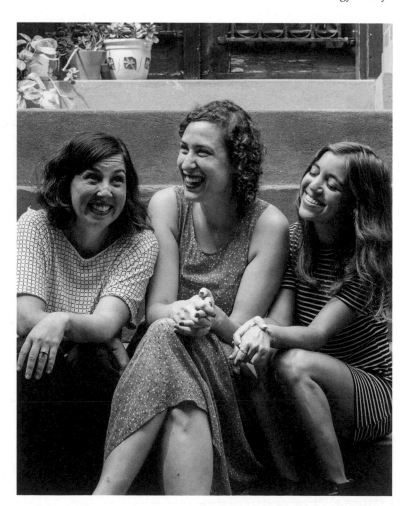

with like-minded folks. We feel so fortunate to be able to have these artists join us at the table and impart their knowledge. Often it felt intimidating to approach people we admired, and then to sit and draw beside them was even scarier. Every Ladies Drawing Night, we would grapple with these insecurities at first, but eventually we'd rid ourselves of them over the course of the evening.

We photographed and recorded each night and summarized them in these chapters. We included instructions so you can do similar projects, as well a supply list at the end of each chapter so you can try or buy our favorite tools and materials.

Our intention for this book is to invite you to be part of our evenings. We can't fit everyone around the drawing table, but with this book at least we can share what we did and what we learned and hopefully inspire you to create your own drawing nights. If you do, make sure to invite us, too, by sharing them with #ladiesdrawingnight. We can't wait to see what you make.

xoxo
Julia, Leah, and Rachael

Here's how you can do it:

GATHER A GROUP OF FRIENDS TO DRAW WITH.
If it's your first drawing night, it can help to limit the guest list to just a few people you feel comfortable with. A small group tends to stay more focused and on track and creates a more intimate environment.

MAKE SURE TO GRAB SOME SNACKS AND BEVERAGES.
We can't make it through a night without a bag of chips and a bottle of wine on the table. (And eating dinner first helps, too!)

LAY OUT YOUR SUPPLIES, AND DON'T BE AFRAID TO SHARE!
Swapping materials gives you the chance to find your next favorite pen or paint color.

PICK A THEME.
If you don't know where to begin, having a theme in mind can help you get started, and it's fascinating to see the different ways everyone interprets it.

TALK ABOUT YOUR WORK AS YOU GO.
One of the best parts of drawing with friends is being able to hear opinions and learn from each other.

LAY OUT YOUR FINISHED DRAWINGS AT THE END OF THE NIGHT.
It feels great to see everything together and it helps you see your progress from week to week. And don't forget to take pictures!

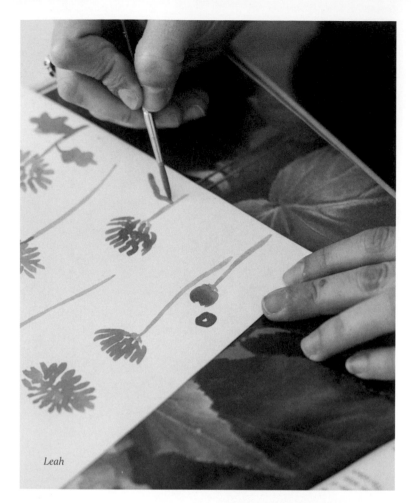

Leah

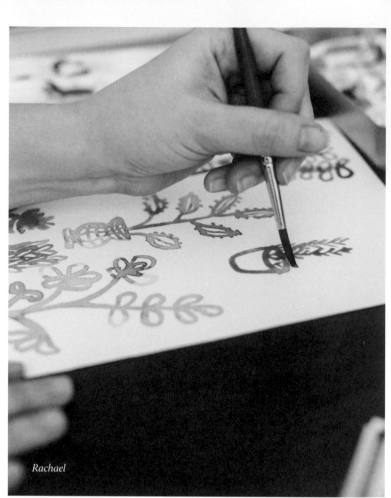

Rachael

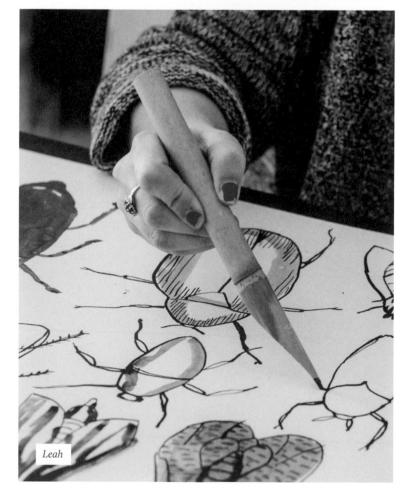

Leah

> "
>
> Ladies Drawing Night has given me a space to try out new ideas and then turn the good ones into real projects. So many pieces that begin in my sketchbook during a drawing night become my next licensing job or ceramic piece. I've also had the opportunity to work on completely new-to-me endeavors (such as this book!) all with the support and encouragement of Rachael and Julia. I'm so lucky to absorb their wisdom every week and also just have a time to talk, laugh, snack, and draw.

LEAH

> Trying to squeeze Ladies Drawing Night in each week can be a challenge, but after everyone arrives, our supplies are out, and the drawing session starts humming along, my energy and mood lift. I often feel so high-spirited by the time we finish that I can't sleep. The net effect of all these evenings is that I've finally gotten over my precious and—dare I say it—neurotic relationship to drawing. The barriers have been lowered, and the final drawing is less and less my reason to put pen to paper.

RACHAEL

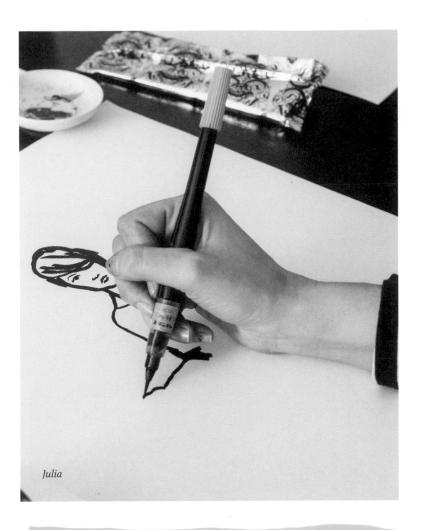

Julia

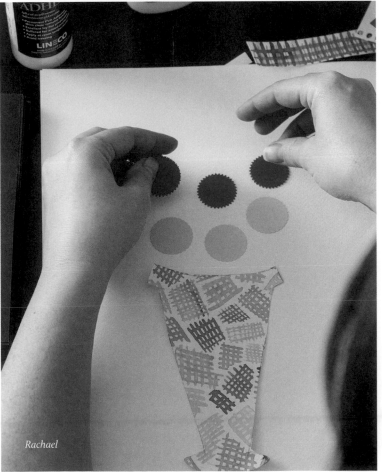

Rachael

> When I wake up in the morning after a Ladies Drawing Night, I am refreshed. Those evenings are set times I give myself each week to try something new and develop my illustration style. With the influence of Rachael and Leah, that usually means loosening up my drawings. I don't think I would have ever attempted using a brush pen if they hadn't pushed me. Now I carry one in my bag in case I want to quickly sketch. It is those small suggestions that have had a lasting impression.

JULIA

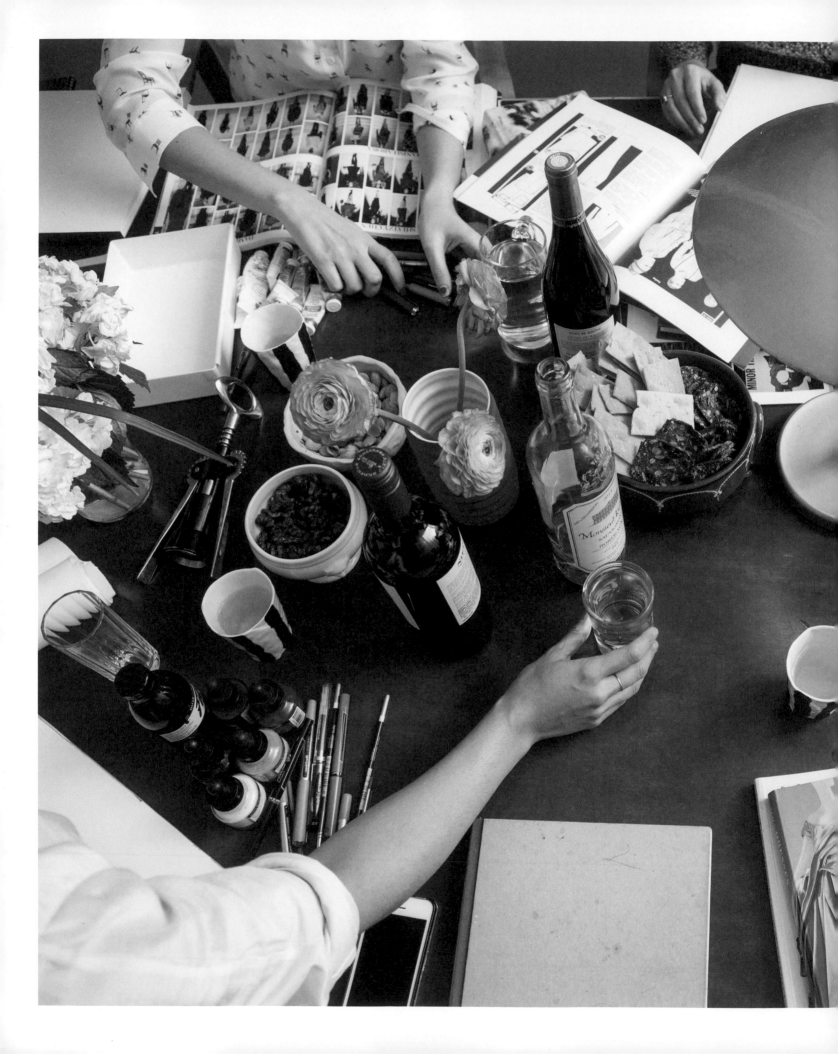

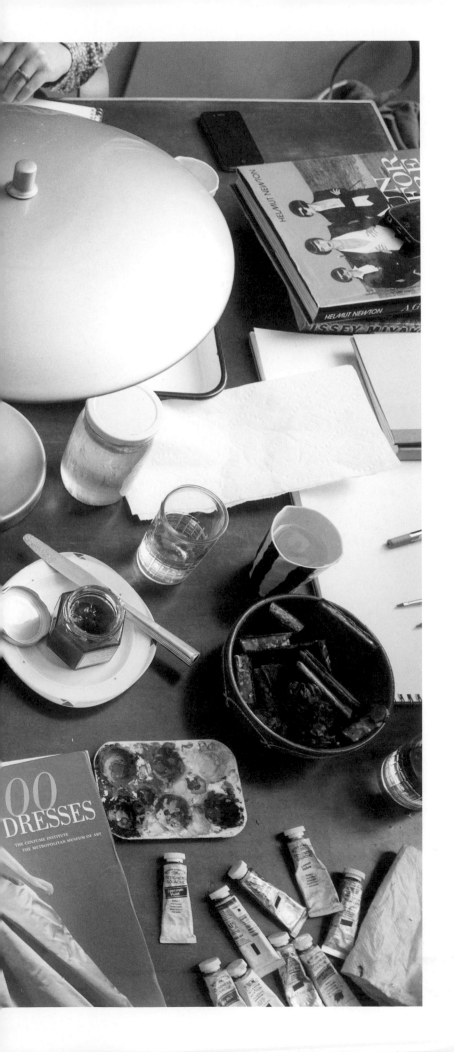

Drawing On Style

with Joana Avillez and
Lauren Tamaki

where Joana's loft
in Tribeca, Manhattan

We're drawing fashion as an excuse to depict the figure all dressed up. It is a chance to use pattern, form, color, shape, and texture. Rendering these styles allows us to access part of another world—these outfits are unlikely to hang in our closets, but this is an imaginary way of trying on those clothes. It's like playing dress-up.

Inside Joana Avillez's loft is a rolling library ladder and long green tables with built-in lamps, flanked by large drawing tables and flat files. Joana lives and works here, spending her days illustrating for a variety of clients. Lauren Tamaki arrives at the loft from her job as an art director, where she spent her workday styling a photo shoot. We spread out our paints, paper, and lots of snacks before getting to work.

JOANA has a history of working on fashion-related illustrations, from live drawing at the Met Ball to creating comical sartorial portraits for Refinery29. She created the charming but sophisticated illustrations for producer, actress, and author Lena Dunham's book, *Not That Kind of Girl*. She's passionate about "personal style," something you pick up on as soon as you meet her.

Trained in traditional sewing and pattern drafting, **LAUREN** spent four years in fashion school before deciding it wasn't for her—"I only finished because I like finishing things." She then went on to study graphic design and illustration, which led her to her many roles today. Lauren is often busy after hours doing freelance illustration work for a variety of sartorial clients. She arrives having just finished some drawings for designer shoemaker Loeffler Randall earlier in the week, so she is warmed up and ready to go with her colorful acrylic inks.

FOR REFERENCE, Julia lugged a *Vogue* runway book, *100 Dresses*, and *Racinet's Full-Color Pictorial History of Western Costume.*

Rachael prepared by printing some images of ska kids and tucked them into the book *Skinhead* by Nick Knight. "I thought about it a little because I don't usually draw fashion and I didn't want to get stuck. I used to be really into ska music and culture, and I would study and copy the way those kids dressed obsessively."

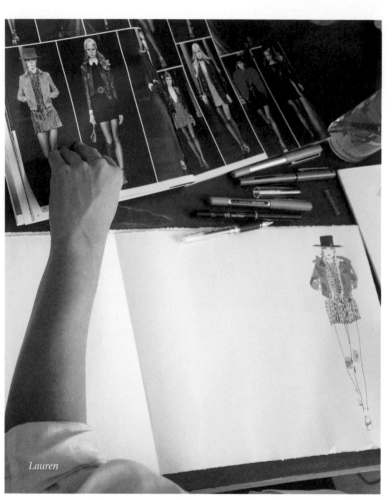

Lauren

Lauren brought copies of fashion magazines to help her draw specific looks. Even though Joana works from her imagination, she took out some of her favorite designers' monographs from her shelves—a book of the works of photographer Helmut Newton and another on fashion designer Issey Miyake.

As we all hunch over our paper, engrossed in our mark-making, we jump in and out of conversation about what we like about drawing clothes. Is there a sense of embodying them as we draw them? Is this our closest chance to wearing an Yves Saint Laurent gown or being a model on the runway ourselves? Or is this an excuse to draw the figure—tall and thin with flowing fabrics?

Julia's figures wind up out of proportion with stretched bodies and tiny heads, exaggerating the model's elegant features. Lauren uses different line weights and brushstrokes to capture the varying qualities of the fabrics—a bigger brush for chiffon, a fine Uni-ball pen for the graph-lined pattern on a dress. Leah flips through the pages of the dress book, painting silhouettes in one color and adding details later with a finer brush. She imagines new patterns and colors for the dresses rather than simply recording what they looked like. Rachael's drawings evoke a sense of nostalgia. We all start talking about what we used to wear as teenagers and how that has evolved over the years.

Leah confesses, "I used to try to dress like Mary-Kate Olsen in high school, buying really big T-shirts, bangles, and cowboy boots at thrift stores and flea markets."

Joana brings out an old drawing she made when she was a child, of a girl in a pattern-filled dress, and we all sigh "awww . . ." in unison, confirming that we all drank a bit too much wine.

We pack up our supplies and drawings and hug good-bye. Rachael is a bit disappointed: "I'm always just getting warmed up when everyone's like, 'Okay, time to head home.'"

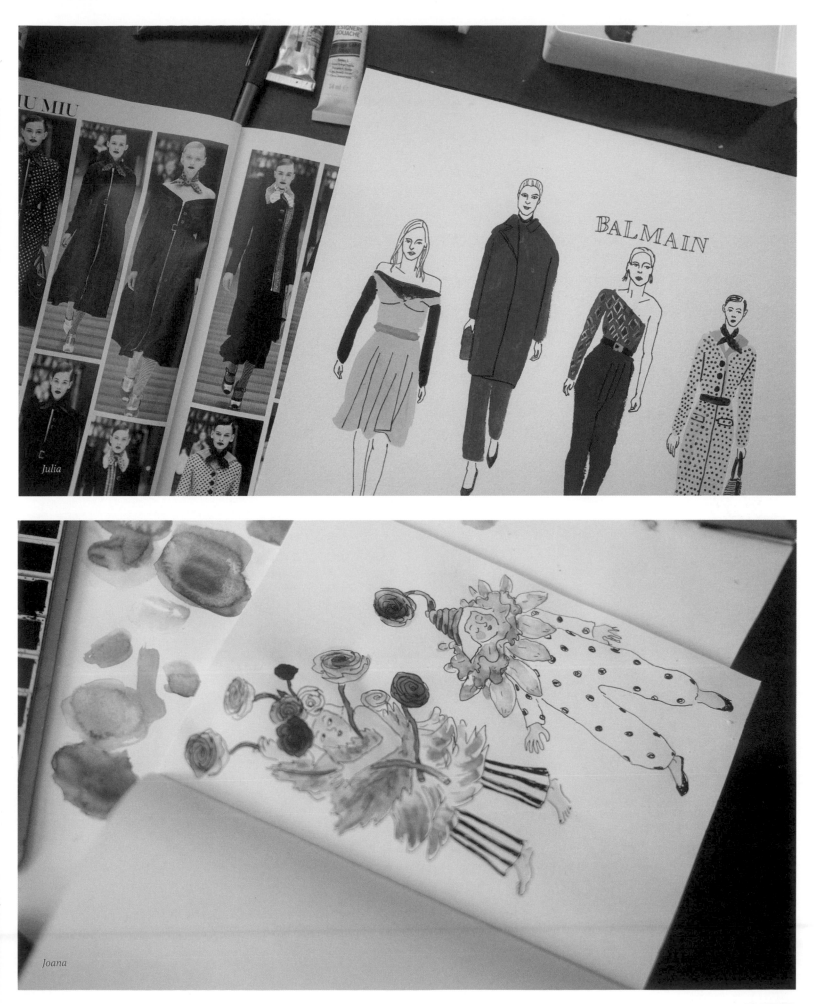

Julia

BALMAIN

Joana

"

In general, I draw what comes from my head. I really don't ever use photo reference. I guess if I have to make sure I know what something looks like, a certain building, for example, or a cow, I would double-check using an image search. Four legs, a tail, see where the nostrils are . . .

JOANA

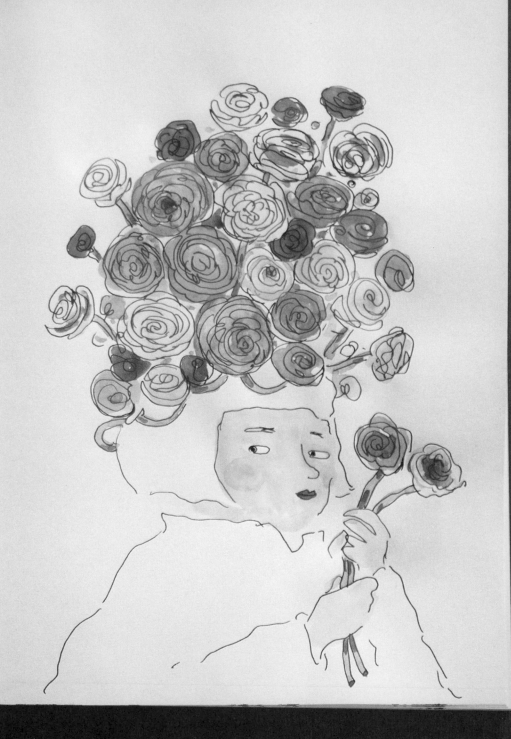

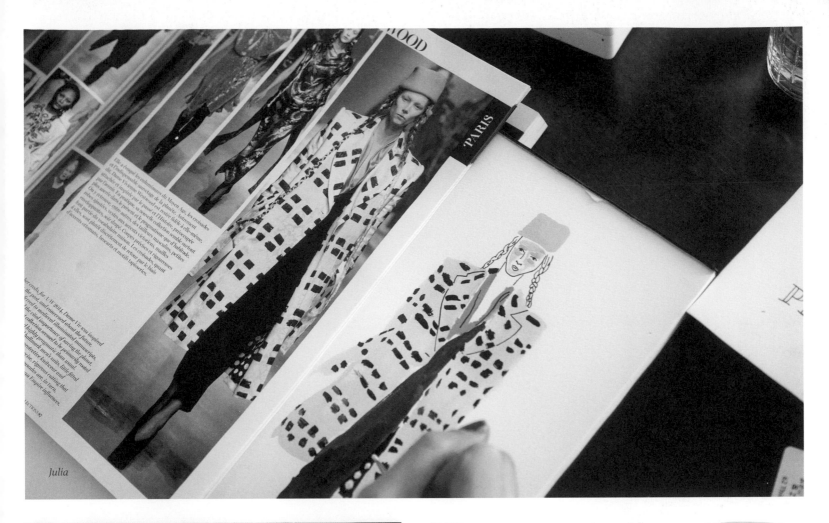

Julia

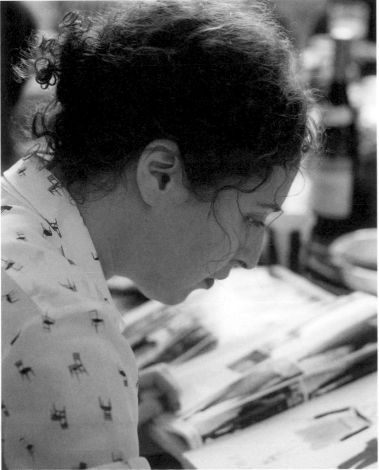


"

This look is so crazy! The more weird the clothing, the more fun it is to draw. This is almost like a costume.

JULIA


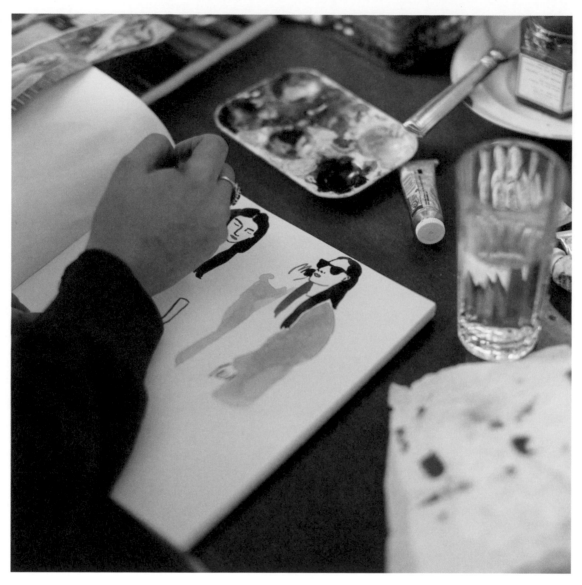

"

I love how my sketchbook lays flat and I can paint all the way across a spread. It's the perfect shape for lining up a bunch of figures, either from street-style photos or runway shows. I've been using the same brand and size of sketchbook for many years. It's the binder board sketchbook by Kunst & Papier, and I always buy the 8-inch square.

LEAH

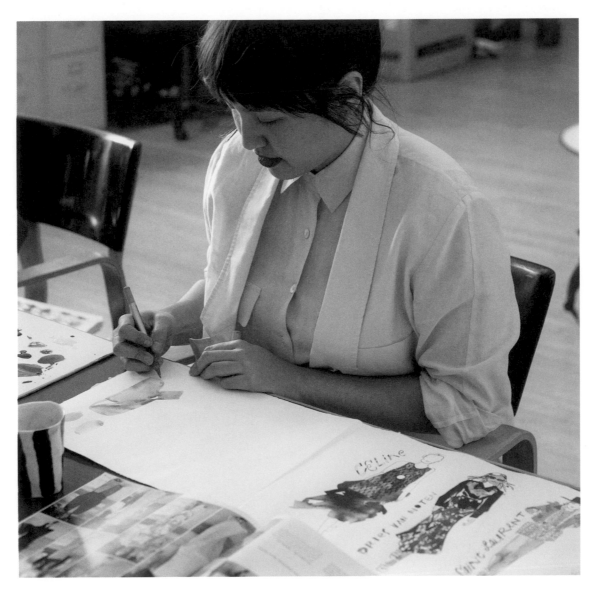

"

I use watercolor Moleskines. Talk about precious, it's very expensive. . . . It makes you feel pretty cool, but then you mess up a page and you feel terrible. And then you tearstain it. Then you just rip it out. A drawing teacher once said, 'Good drawings happen sometimes—just sometimes. And you don't know when it's going to happen.' I think about that all the time. You just have to keep on drawing because then your odds are better.

LAUREN

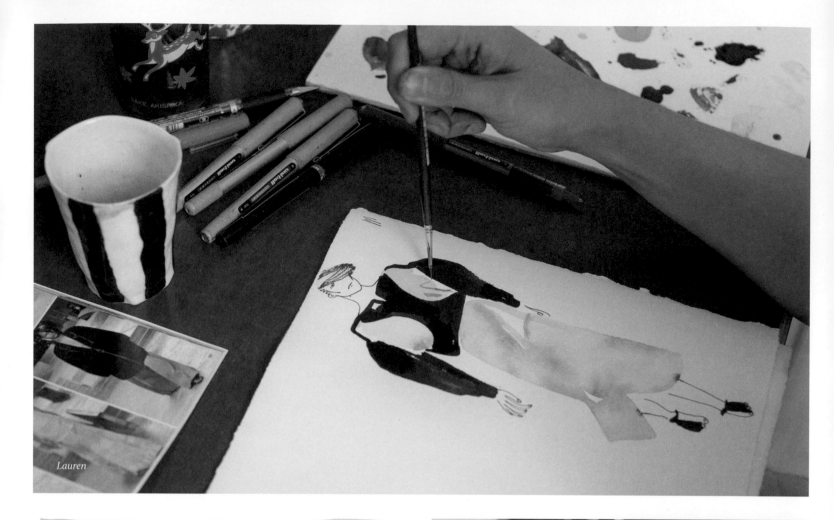

Lauren

I'm very reference-based. If you look through my sketchbooks, there are a lot of table settings and people on trains. I take a lot of photos of people and draw them later, just because I don't have my sketchbook with me.

LAUREN

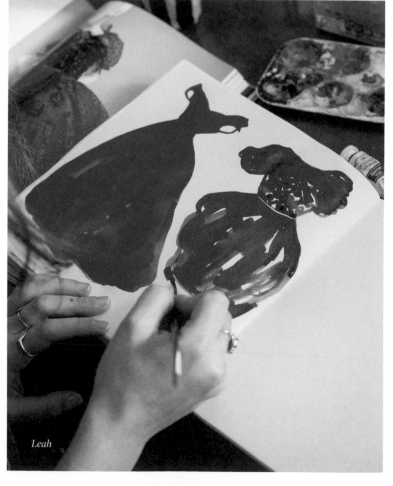

Leah

Drawing on Style *Ladies Drawing Night*

> "
> When I'm not sure how to start, I just draw simple dots all over the page. Then I start building on top of them. I love drawing graphs and dots, so I'm incorporating those motifs into the clothing.

RACHAEL

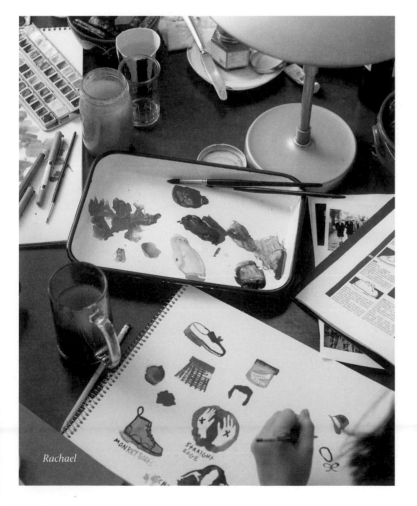

Rachael

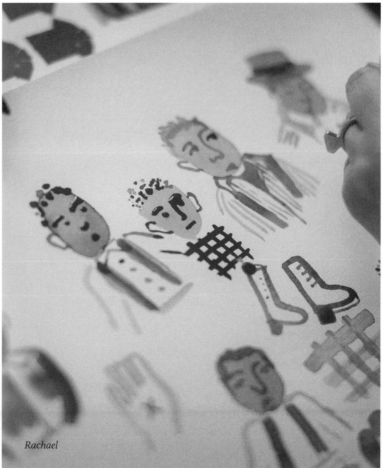

Rachael

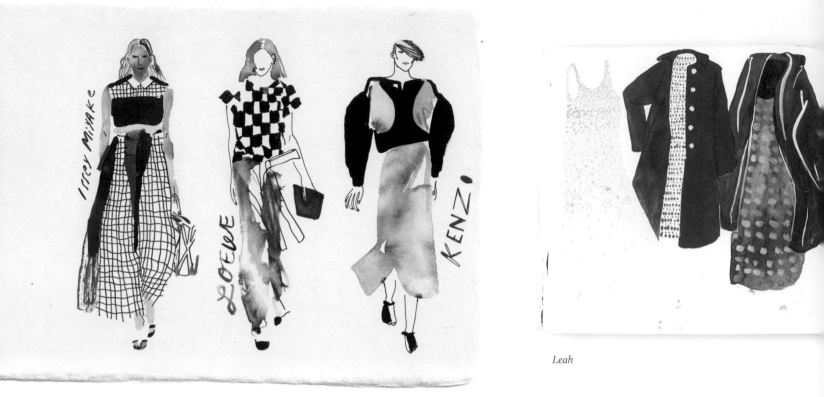

Lauren

Leah

Joana

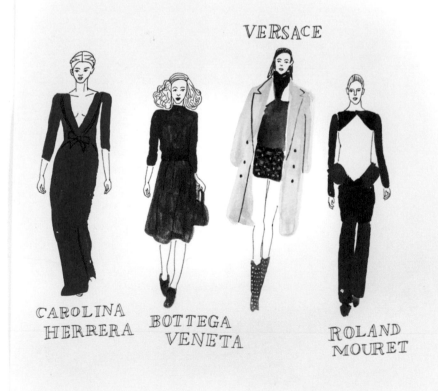

Julia

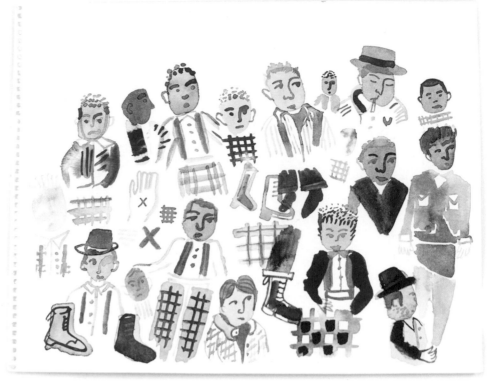

Rachael

OUR TAKEAWAY

Drawing figures can be especially intimidating, even for experienced illustrators. We all have different ways of getting something on paper. Opening a magazine for inspiration or drawing some shapes on a page and seeing where they lead are ways we get started.

HERE'S HOW YOU CAN DO IT

- Gather references (unless you are working from your imagination); catalogs, books, magazines, and websites are all great. If you're using the Internet, you might want to print out your imagery so you aren't distracted during the drawing session.

- When drawing figures, some people find it easier to start with blocks of color, others with lines. Try out both if you're not sure.

- Search for shapes, patterns, and textures in the clothing that can add interest to your drawing. By focusing on these decorative elements, you don't have to worry as much about getting the proportions of the figure exactly correct.

HERE'S WHAT WE USED

Joana Uni-ball pen, Schmincke watercolors, Muji sketchbook

Lauren Watercolor Moleskine notebook, Daler-Rowney waterproof artist ink

Julia Uni-ball pen, Winsor & Newton gouache, heavyweight hot-press watercolor paper

Leah Winsor & Newton gouache, Kunst & Papier 8-inch square binder board sketchbook, Winsor & Newton Series 7 watercolor brush

Rachael Winsor & Newton watercolor and gouache, Coventry vellum surface watercolor paper from New York Central Art Supply, various watercolor brushes

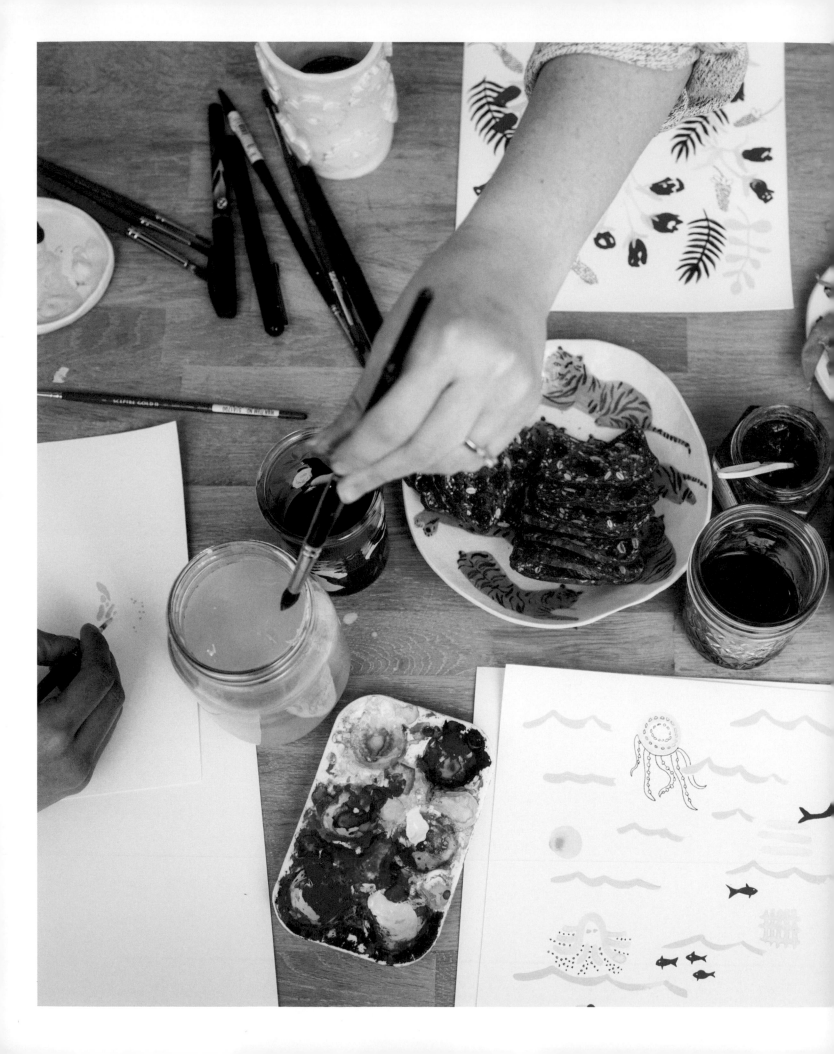

All Together Now

with Rachel Levit and
Monica Ramos

where Leah's studio in East
Williamsburg, Brooklyn

Working as an illustrator can often be isolating—drawing alone at your desk with a computer screen between you and your clients. Between jobs, it's refreshing to work on collaborative projects with creative friends. This evening we meet at the studio Leah shares with Rachel Levit and Monica Ramos to take turns drawing and painting on the same pages.

Walking up the big industrial staircase to the studio, Julia expresses her fears about a collaboration night. "I just have no idea how this will turn out. It's so unpredictable. I've done drawing collaborations with friends and they have been a mess, a fun mess—but maybe not something you want to share in a book." But Rachael is confident. "These girls are super talented. How could this go wrong?"

MONICA grew up in the Philippines, and relocated to New York right after high school. Though she quickly became known for her busy and bright watercolor scenes, she wasn't planning to become an illustrator at first. "I moved here when I was seventeen," Monica says. "I thought I was going to study business or environmental science; I thought I just should do something more helpful for the world. But I learned illustration is actually quite helpful."

RACHEL L. chimes in—"I like that editorial illustration allows me to be involved in global issues, and I have the opportunity to interpret topics I believe in through my work." Rachel hails from Mexico City and is often commissioned for pieces covering current events in her home country. Her poignant drawings appear alongside some serious articles for clients such as the *New Yorker* and the *New York Times*. Rachel regularly travels between New York and Mexico City and is involved in the art and illustration communities in both cities.

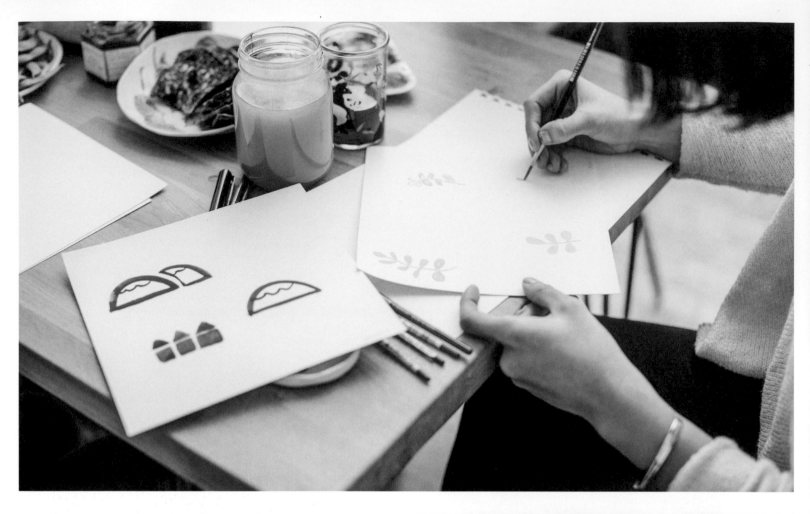

LEAH, RACHEL L., AND MONICA met in the illustration department at Parsons School of Design. There, they found they shared a visual affinity, and when they graduated they decided to share a studio space together in East Williamsburg, Brooklyn. Monica admits, "I was a little intimidated to join the studio because I didn't know if I could make enough money to pay for it. I was so used to working in the living room and being in my house alone. It's helped me stay motivated and it's much better to have a separate space to work outside of my house."

For the night's event, we set up our stuff all around one long table in the middle of the studio. We sit very close to each other so we will be able to pass drawings back and forth easily and see what each other is doing.

"
The best collaborations happen when you trust the other people and their decisions, even if you would have done something completely different.

JULIA

Julia rips ten sheets of watercolor paper from a pad she brought. These are our canvases. Monica pulls out some Japanese Holbein Acryla gouache and we debate colors before settling on Naples Yellow, Pale Lavender, Flame Red, and Winsor & Newton Mars Black. We limit the palette to only a few colors so that even though our styles will be different, the colors will all work together and make the pieces feel cohesive.

We all squirt a little from each tube onto each of our palettes.

"How do we start?" Leah wonders.

"Hmm, what if we limit this even more by subject matter?" Julia suggests. We all agree that would be helpful, so we think of ten things or places that could be the theme for each piece: kitchen, living room, village, mountains, ocean, floral, mug shots, sports, city, and crowded train. Julia writes each topic lightly in pencil on the bottom corner of each paper and we start passing them out.

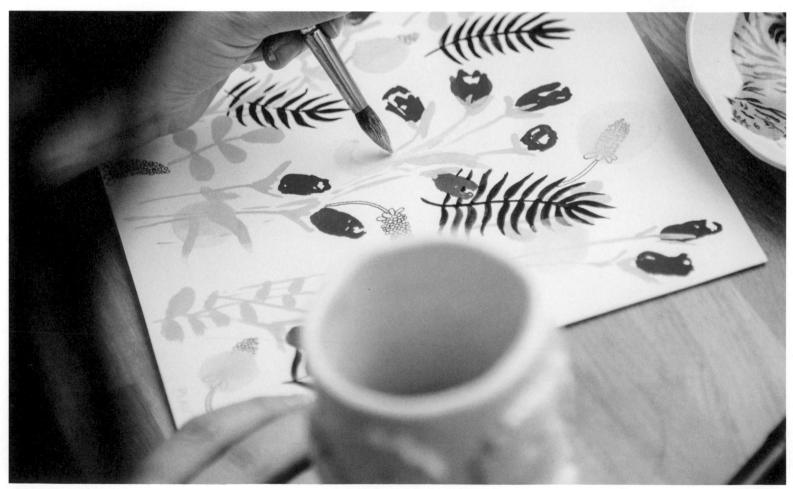

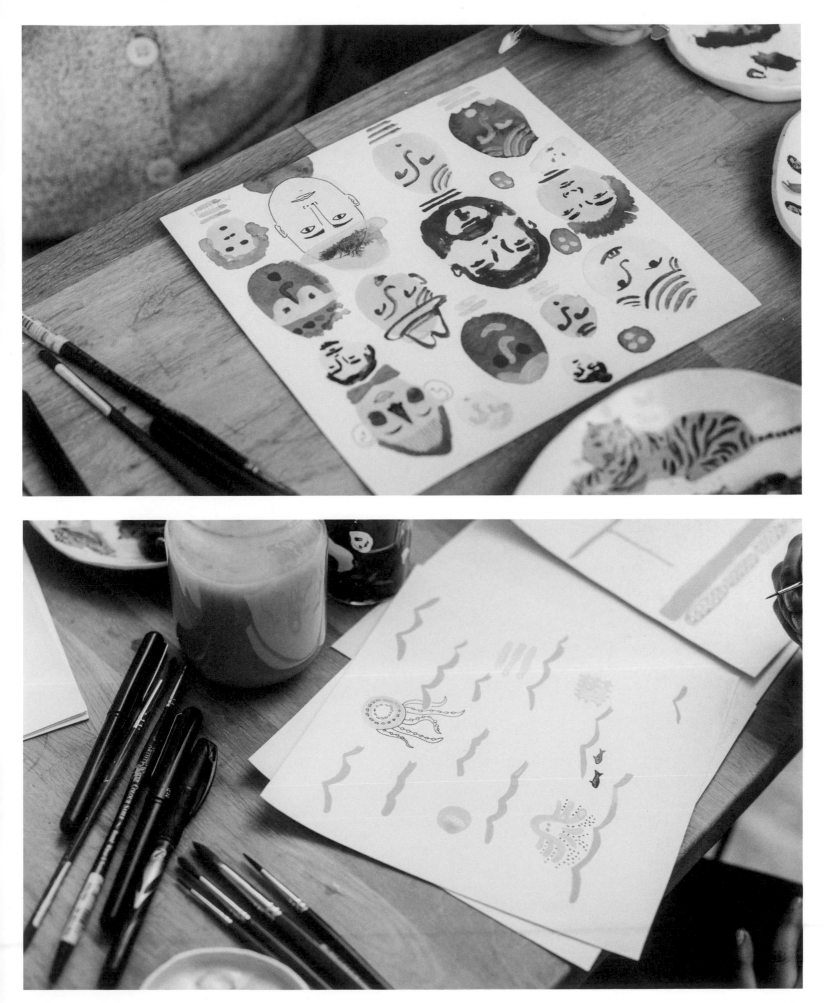

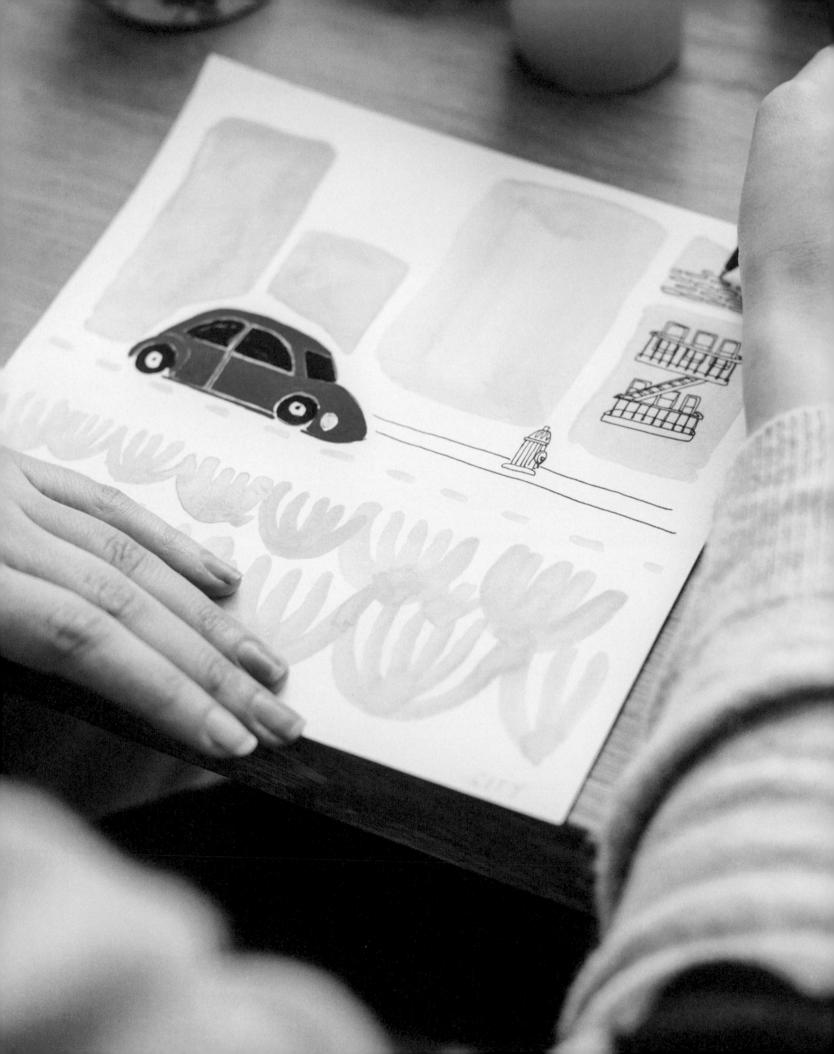

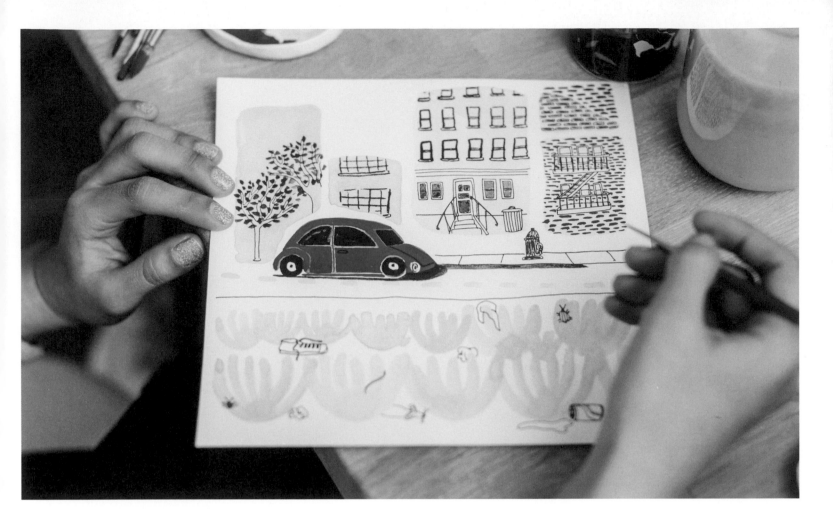

"I'll take kitchen!" Rachael exclaims.

"I guess I can try the living room," Leah says.

We all started painting however we want until we aren't sure what to do next. It is a constant auction house. "Anyone want mountains?" "I got floral over here that could use something." "Hey! Somebody start the sports one, it's still blank!"

We art direct each other by accident. Julia instructs Rachael, "Put some yellow washes here," and then retreats. "Whoops, sorry, I don't mean to tell you what to do!"

Rachael softens. "No, I like it. I'm so used to art directing other people, it's fun to have someone tell me what to do. And also, you're in luck, because I agree it needs yellow."

It is captivating to watch as our drawings continually transform. Rachel L. admits she was not used to that feeling. "It's so hard because you want to control it, but I guess that's the point, to surrender control."

Rachael counters, "I feel free, because I don't feel responsible for any one drawing."

Julia is more pensive. "Everyone will know what I did because I'm the only one using a thin black pen."

Leah fills the subway drawing with many tiny faces. Rachel L. paints spiny black ferns among the color. Rachael makes big splotches of watery color and paints patterns with a messy brushstroke to contrast Monica's clean shapes.

"That one needs something I cannot offer, maybe some thin lines."

"I'm going to put a pillow on this couch."

"Yes! Maybe with fringes?"

We mostly validate each other's decisions. When the paintings start filling up, one of us stops the group to look up and ask, "Okay, is this one done?" and we cheer or suggest some additions—one more fern, another splotch of red, some detail on that face.

When we agree that all of the pieces are finished, we hang them on the wall with removable tape. We have a mini critique. Overall we are happy with the results. While some drawings seem to work better than others, we all had different favorites.

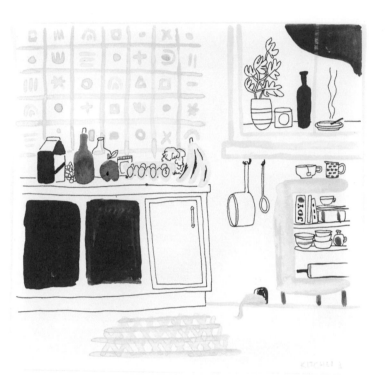

Rachael I don't really love the room one that much.

Leah Really? That's obviously the best one. It has some white space left; it's not filled to the brim like the rest.

Rachael Well, maybe that's why. Maybe it's just not funky enough.

Rachel L. Maybe it's not collaborative-looking enough.

Julia Yeah, it looks like it could have been made by just one person.

Rachael The kitchen one was really fun to paint, but I don't know if I love the whole effect. I enjoyed painting it though. Especially the backsplash. I was designing my own custom kitchen tiles.

Leah I feel like it had stages along the way that were more satisfying than the final, but maybe we overworked it. I still like it though.

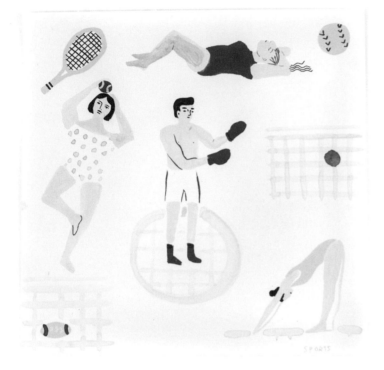

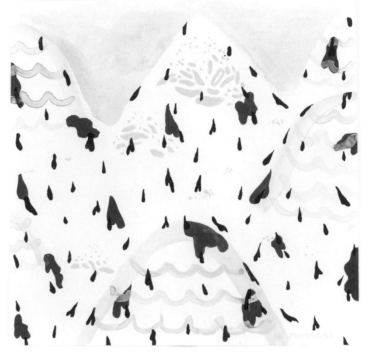

Rachael I love the sports one. And I love the mountains. Those are my two favorites.

Julia My favorite is the city because it came out weirdly dark and strange. I think the city was looking bad at first but you rescued it.

Rachel L. I hated the car I drew at first, but it went through so many of you, and you made that piece work.

Monica The bumper was just a little too low, so I added a shadow.

Julia That shadow makes it feel more eerie. Good call!

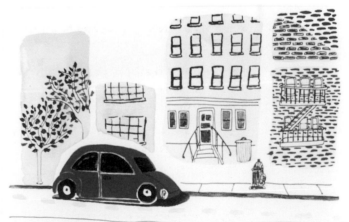

Monica The mountain one is my favorite because it's so unique from the rest of them. It's more abstract. But I like the city one a lot. It's just the gist of a city. The ocean is nice because it's very balanced.

Julia It feels like a pattern. Everything is evenly spaced and the elements are around the same size. There's no real focus.

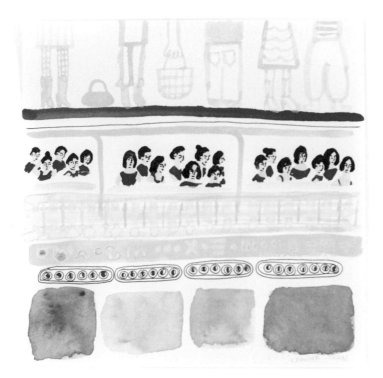

Leah You know what, I *do* like the kitchen. It feels good to me even if I said it was overworked. But maybe if the red wasn't as heavy, it would feel better.

Julia I thought someone would draw on the red spots, but it never happened.

Leah Maybe that drawing isn't finished.

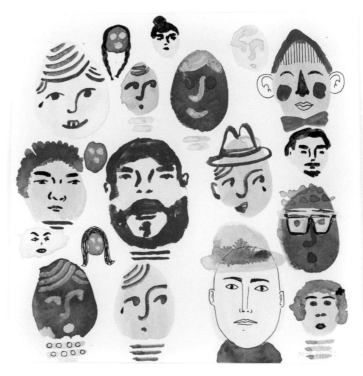

40

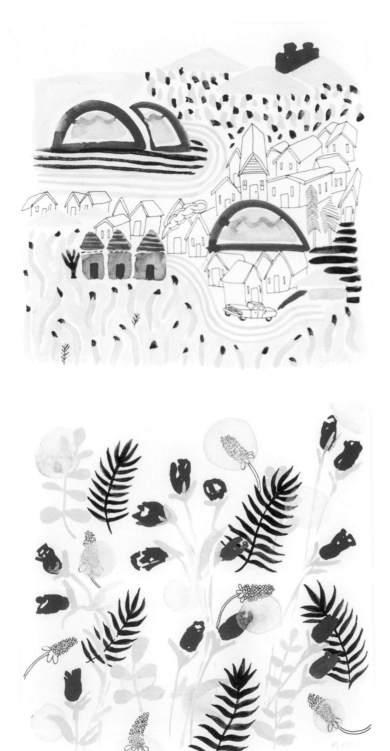

Making limitations on the palette, paper size, and subject matter helped our collaborative process. But this is also something we do with our own solo projects. Sometimes by giving ourselves restrictions, our work is more cohesive and focused.

HERE'S HOW YOU CAN DO IT

- Provide ten sheets of equally sized paper.

- Choose ten themes, one for each sheet of paper. Write the theme lightly in pencil at the bottom corner.

- Pick four colors that compliment each other, and use only those.

- Have everyone pick a drawing and start working until you find a stopping point. (If you're not sure when to stop, try using a timer.)

- Swap drawings, adding to each other's marks and trying to complete the picture.

- A drawing is finished only when everyone agrees it's done.

HERE'S WHAT WE USED

Holbein Acryla gouache in Naples Yellow, Pale Lavender, and Flame Red; Winsor & Newton gouache in Mars Black; 10-inch square hot-press watercolor paper

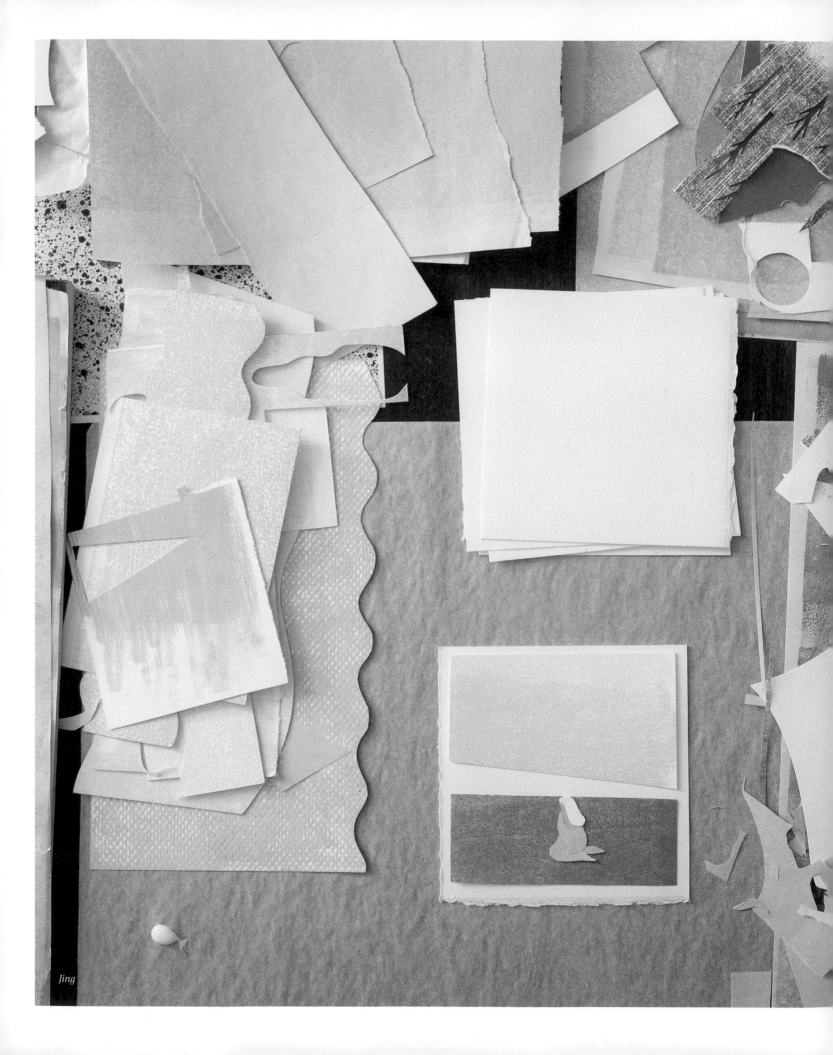

Jing

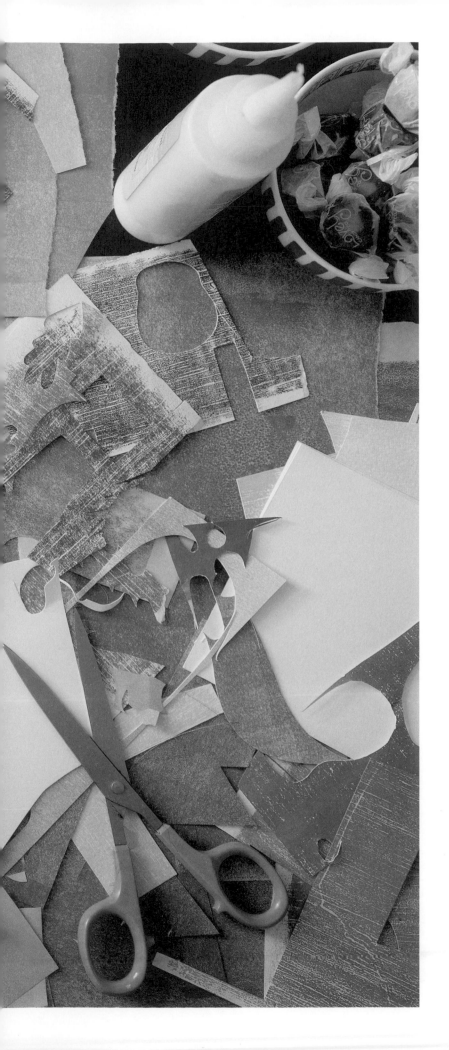

Cut and Paste

with Jing Wei and
Ellen Weinstein

where Rachael's apartment in
Fort Greene, Brooklyn

Tonight we're exploring collage, a process that still feels so much like the cutting and pasting crafts of our childhoods. With collage, you can instantly change a composition and see new shapes form, just by moving around cut pieces of paper. Even the seasoned draftsman may find new, unexpected ideas. It is satisfyingly tactile and immediate.

We meet up at Rachael's apartment in Fort Greene, Brooklyn. We've invited along illustrators and collage enthusiasts Jing Wei and Ellen Weinstein to share their expertise. Sadly, Julia threw out her back the day before and can't make it but joins in on the project from her bed.

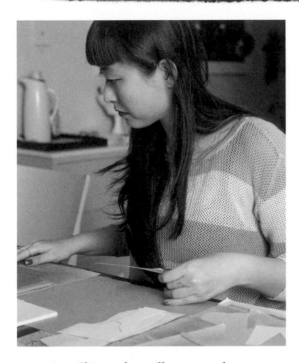

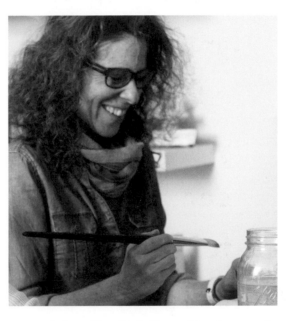

JING is a Chinese-born illustrator who grew up in California and studied illustration at the Rhode Island School of Design, specializing in woodcut printing. After she graduated, she moved to New York and took on a part-time job teaching two-year-olds. "I killed at crafts!" she says. It was there she discovered her affinity for collage. "I have to force myself to draw for fun, but collaging is actually more natural than just putting a pencil to paper." Jing now works as the brand illustrator for Etsy, as a visiting instructor at Pratt University, and on illustration commissions for a variety of other clients.

ELLEN is from New York City and has been working as an illustrator for more than twenty years. Her work has gone through many phases since she first began, and eventually led her to collage. "I started out as a printmaker, and I could just never get a perfect monotype [a simple method of printing], so I would end up cutting them apart and piecing them together. It was pre-Photoshop. Over time they became more collage than monotype." She pushed collage so far that for five years her work was completely 3-D. "I photographed it with a 4x5 camera. Now I'm back to doing paintings and monotypes and cutting them apart again, so it's a little bit full circle."

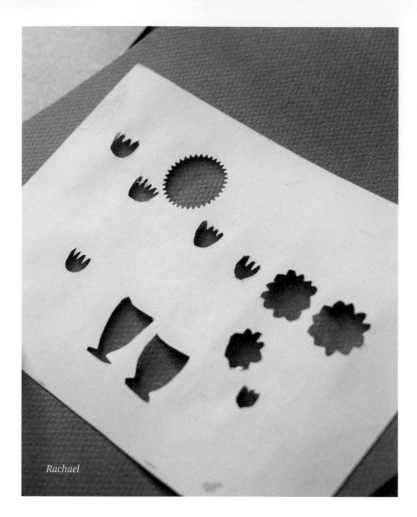

Rachael

WE BEGIN THE EVENING by spreading out our supplies on Rachael's large dining room table. Jing unloads an impressive stock of hand-printed paper leftover from her printmaking work and arranges it by color and size. Leah brought along a pile of paper scraps in various patterns, both hand-painted and printed digitally (like wrapping paper), while Rachael plans to cut into a stack of her old paintings. Ellen is the most prepared, with a toolbox full of everything you might ever need for collage work: many types of glue, an X-Acto knife, scissors, a self-healing cutting mat, brushes in various sizes, a bone folder, paints, pencils, and pens. Every time someone is missing a tool, they call out to Ellen, who usually has exactly what is needed.

Jing dives into her piles of paper, carefully selecting swatches to make a series of small images, around 4 inches square. She cuts out tiny shapes with a sharp pair of scissors, moving them around until the pieces are ready to be glued down. "I do everything freehand. I start with big pieces and get a sense of the composition and what feels right and then zoom in on details from there," she says. She also keeps a small dab of liquid glue on the tip of a finger to adhere pieces with ease and to avoid a big gluey mess.

Leah talks about how collage informed her work early on: "Nobody taught me how to use Photoshop in school. When I was figuring out what my work was, I spent a lot of time cutting out parts I didn't like and moving things around and then adding back into it. I think that's why drawing and collage seem to go hand in hand for me." Tonight she mixes drawing with the cut paper, arranging blocky paper clothing around painted pink figures.

Ellen also mixes collage and painting with ease. She works in her Moleskine watercolor sketchbook, layering vintage photos with cut-out drawings and layers of gouache. "I started a sketchbook project when a friend of mine gave me a box of photos—so I've been using the photos in their entirety and just making paintings on top of them instead of cutting out a lot of different things," she says.

Rachael makes collage material from her paintings, cutting shapes out of watercolor grids, dots, and arches. The simple, geometric shapes she cuts transform into a tabletop, a vase, and flowers once she affixes them to paper. She also has fun with fancy paper punches. "If anyone wants any punches, let me know! I've got scalloped, I've got sunbursty, I've got stamp-looking, too, like a scalloped square."

By the end of the night there is an enormous pile of scraps everywhere. They are almost too beautiful in themselves to discard.

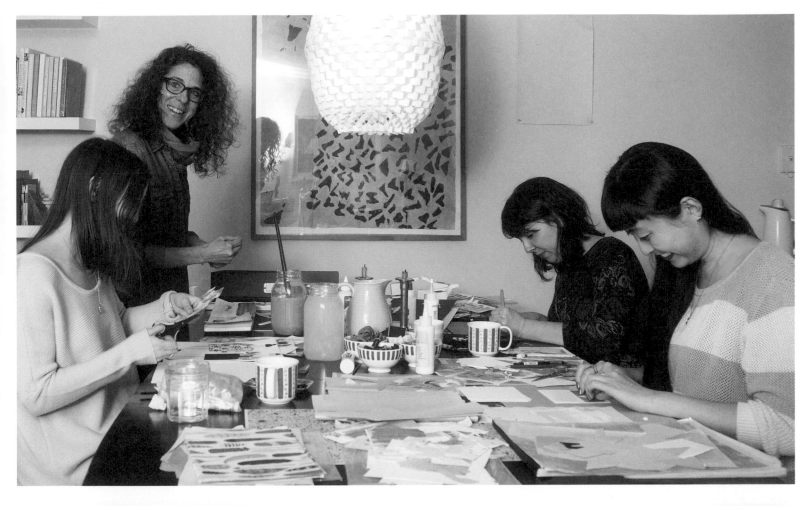

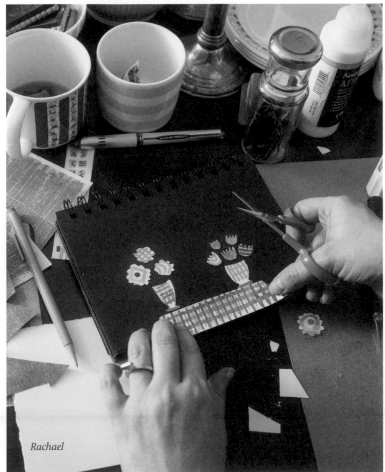

Rachael

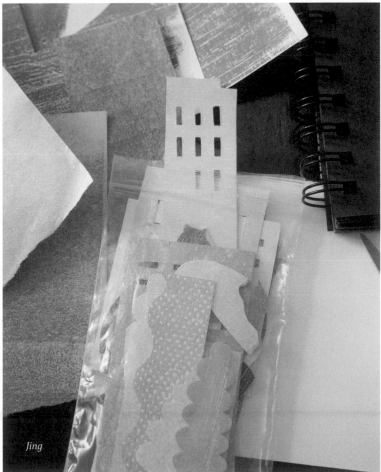

Jing

"

I'm free-form collaging right now, so it's very relaxed and easy. I'm working so small I'm able to make something quickly and then let it go.

JING

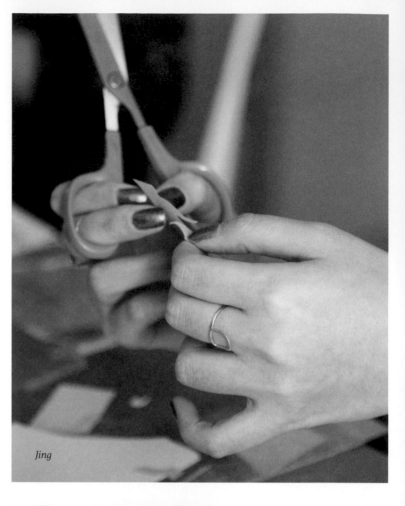

Jing

"

These are just plain pieces of paper that I printed on, so the texture comes from the block. Some of this more speckled, even texture comes from a piece of MDF, and this more weathered texture comes from an aged piece of wood. I roll the ink onto the wood directly and then just put the paper over. These are technically monoprints, but they're just nonrepresentational.

JING

Jing

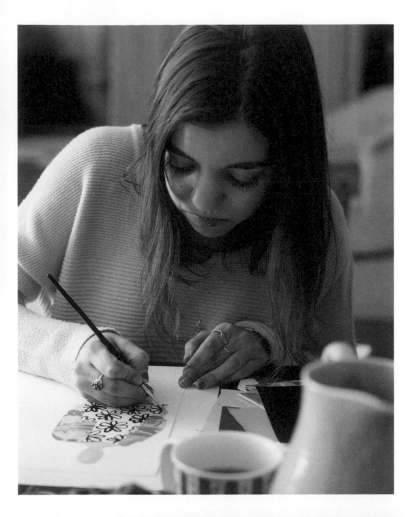

Drawing fashion is the first thing I thought of, because a lot of the paper I brought with me has patterns on it. I'm starting with the clothing and using the fun paper that I have and then I'm painting the figures around that. I'm trying to have a bit of balance between what is painted and what is paper.

LEAH

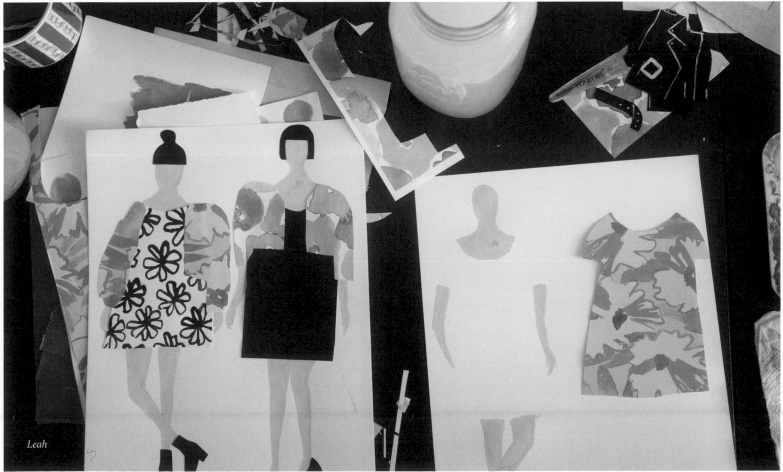

Leah

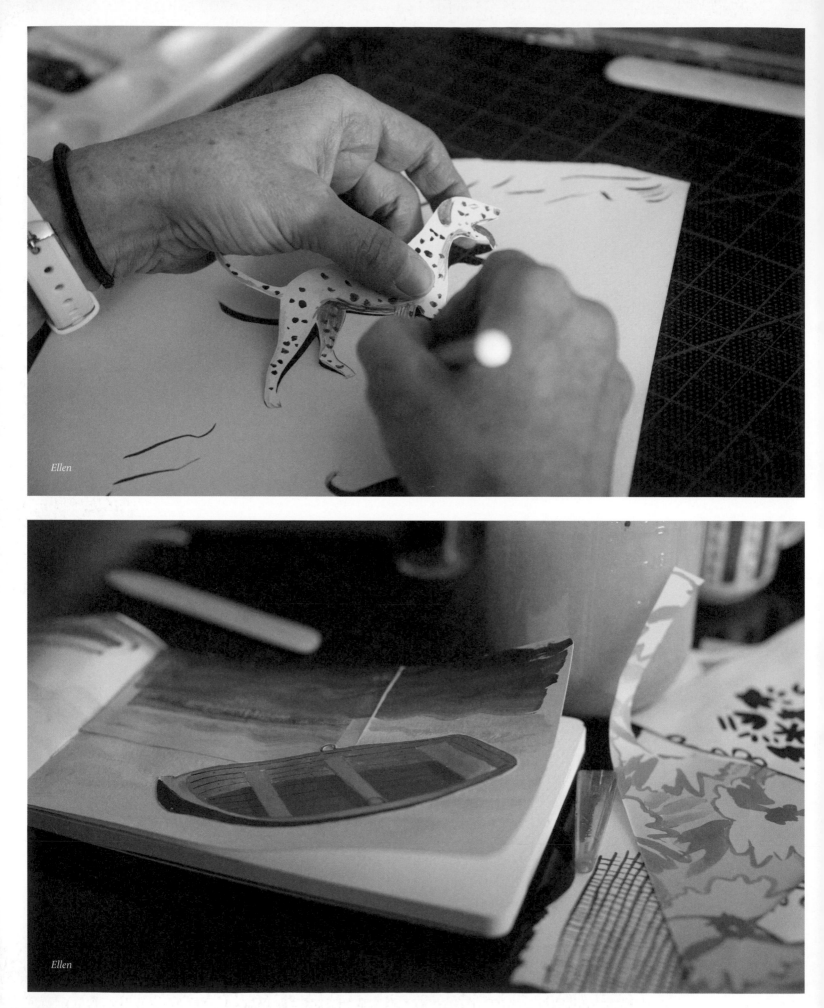

Ellen

Ellen

Cut and Paste *Ladies Drawing Night*

"

It's pretty rare I use something from a magazine, for copyright reasons, and I just like making the things more. It can be an enormous waste of time looking for something that's perfect from a magazine when you can just make it yourself. I'd rather just take the photo or paint it than spend hours looking for the perfect thing.

ELLEN

"

My process changes; it depends on what I'm doing. I like to work with some parameters; I have a really hard time working with no boundaries whatsoever. Whether it's a theme or the size of the paper I'm working on or a color, I need something to start with. Even just having this sketchbook page as a size is something to start with. Whereas if I'm starting with lots of scraps of paper, I can just keep changing what I want to do and not glue anything down.

ELLEN

"

I prefer X-Actos for things that are more precise or if I'm cutting heavier surfaces, like cardboard or chipboard. Anything that's heavier than a really thin paper. But I like scissors for things that you intentionally want to look a little more rough-edged.

ELLEN

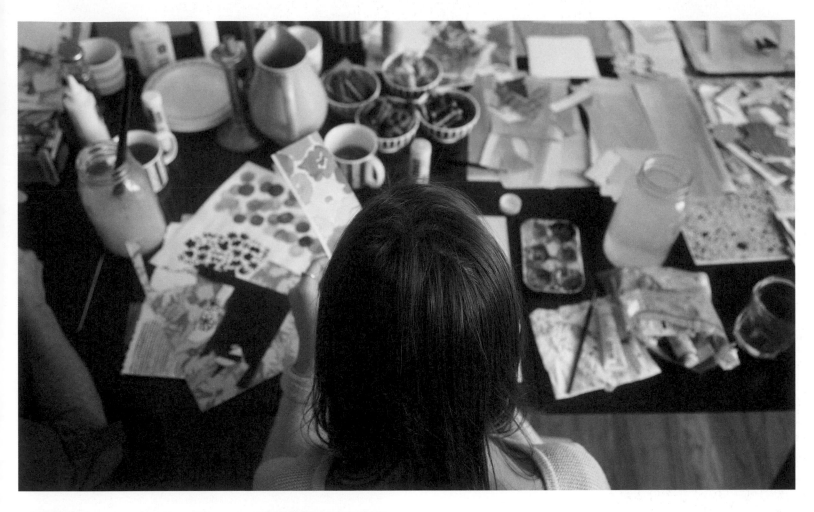

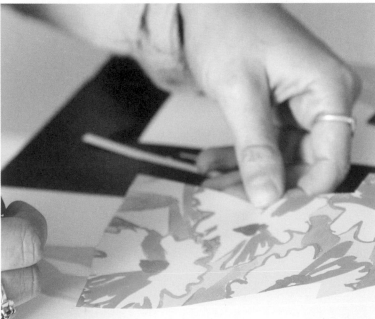

Leah

> "
> Collage makes your work less precious; you can do a bunch of drawings and then pick the one you like the best and cut it out and put it with something that it fits with.
>
> _____
>
> **LEAH**

Jing

Rachael

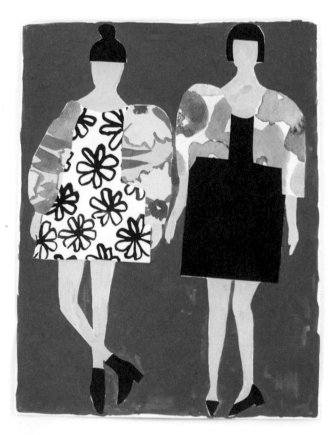

Leah

Julia

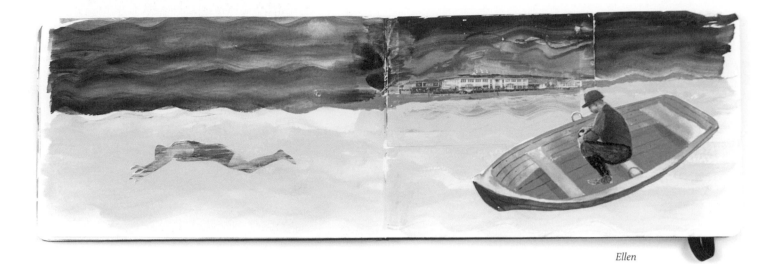

Ellen

OUR TAKEAWAY

Old paintings and drawings can have new life in collage. So can old wedding invitations, hangtags, movie tickets, the insides of security envelopes, and scalloped candy wrappers. Collecting and organizing repurposed papers by color, size, and type can be a creative project in itself. You can make meaning out of found scraps, which can inspire interesting projects . . .

HERE'S HOW YOU CAN DO IT

- Collect a bunch of collage material. Any colored paper, painted paper, old drawings, photos, pages from books or magazines, or anything else you have on hand will work perfectly.

- Cut into your collage material using scissors or an X-Acto knife on a self-healing cutting mat. You can also use cardboard if you don't have a mat, but it may dull your blade quicker, and be careful not to press too hard and cut through the cardboard.

- Place your cut pieces on your foundation paper. Try arranging and rearranging the composition in a few different ways before settling on one.

- Affix your pieces. Glue sticks, liquid glue, and tape all work well.

HERE'S WHAT WE USED

Ellen Moleskine watercolor sketchbook, Winsor & Newton gouache, various Winsor & Newton brushes sizes 000 to 2, X-Acto knife with #11 blades, glue stick, photos

Jing Previously hand-printed paper (newsprint, Rives Lightweight, Somerset Satin), scissors, Lineco Neutral pH Adhesive

Leah EK Success small precision scissors, UHU glue stick, origami paper, colored construction paper, old paintings, patterned paper, Winsor & Newton gouache, Winsor & Newton Series 7 watercolor brush

Rachael Discarded watercolor paintings, X-Acto knives, glue stick, black paper, Martha Stewart decorative paper punches

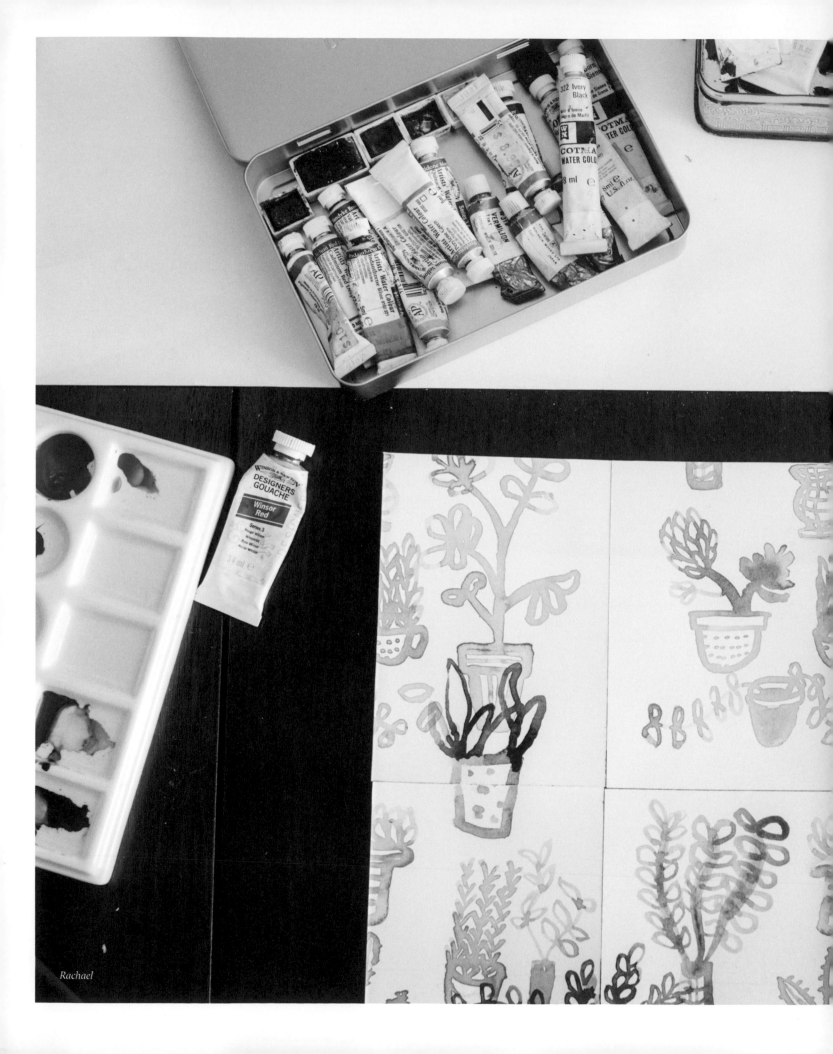

Rachael

Pattern Play

with Ellen van Dusen and
Lotta Nieminen

where Rachael's apartment in
Fort Greene, Brooklyn

Patterns are found everywhere in nature. Spirals, waves, cracks, and symmetrical forms surround us. This may be why we find patterns so visually appealing. For centuries patterns have appeared in various decorations, such as wallpaper, textiles, and apparel. We're about to make our own tiles for a repeat pattern. Once we create a tile, we can use it to make a full pattern.

Our pattern-making technique is very simple and requires just a piece of paper, some drawing tools, scissors, and tape. We invited pattern-making guests Ellen van Dusen, the designer behind the apparel and homeware brand Dusen Dusen, and graphic designer and illustrator Lotta Nieminen to impart their wisdom.

ELLEN grew up in Maryland. Her parents are both architects, so she developed a sense of math and design early. Ellen studied the visual system and neuroscience in college, so her career trajectory may seem surprising. "I always made clothes for myself," she says. "I was getting compliments on my clothes, so I started selling them, and it worked, so I kept going. I think my education informs my sense of design, but I don't actively think about it when I'm making things." Ellen designs both the clothing style and the pattern of her fabrics, and is known for her graphic, geometric prints. Dusen Dusen is sold online and in over sixty stores globally.

LOTTA is originally from Helsinki, Finland, but she attended the Rhode Island School of Design for an exchange semester. After working as a designer for a fashion magazine, interning at the famous Pentagram design studio, and landing a job at a small fashion branding firm called RoAndCo, Lotta decided ultimately to work on her own, designing, art directing, and illustrating for a variety of clients. "I remember trying to do pattern work at school, and I always thought that I didn't like it at all. It was very difficult to think that way," she says. "Somehow, maybe only a few years ago, I wound up in a project where they needed a pattern and I was forced to figure it out. Then, like most things, once it was in my portfolio, more of those commissions started coming in."

WHILE THE THREE OF US—Leah, Rachael, and Julia—have been creating patterns for years for wallpaper, apparel, and home goods, we knew there was something we could learn from Ellen and Lotta. We are going back to the basics for pattern night, and starting with our hands. This simple method for creating a repeating tile is something Julia has taught at workshops and classes but not something any of the rest of us had tried before. We all use the same size paper and jump into it. Lotta and Ellen both decide to make their designs using cut paper. Ellen says she will often start with cut paper to get ideas for shapes. The rest of us take to our drawing implements to complete the first step: to fill the page as much as we can without touching the edges. Leah, Rachael, and Julia all draw plants and flowers, while Lotta and Ellen cut shapes out of bright colored papers and arrange and glue them to the page.

While we work we compare our processes in our daily practices. Ellen explains, "I have some basic flats [an outline drawing of a piece of clothing], and I'll sketch stuff inside of there and see what's speaking to me. Then I will bring it into the computer and do a trial of a million versions of the same idea. But usually within a collection, there's a quality of line I use with each print. For example, one season I had a lot of verticals with pivoting lines."

Lotta admits, "I don't do sketches. I do all my patterns in the computer in Adobe Illustrator. In a way, I'm a little lazy about it. I build a square and fill it up, making sure enough stuff is close to the edges, and then I just repeat and multiply it."

We also discuss why we like pattern projects so much. Lotta says they are the most thrilling because "the design gets applied to all different things and surfaces. The Liberty print I made will now be a collared shirt. It's nice to see it in applications that are not just paper. Being an illustrator, you are quite often working with paper implementations, so it's quite delightful when it's off the page."

For the next step, we cut our tiles in half, swapping the two halves so the white edges match up, and taping them together again. We then cut the tile in half again in the opposite direction, swap the halves, tape them together again, and then go on to fill in the new white space in the center of the tile with more design. Lotta decides not to cut her tile because she was afraid of all the small cut pieces falling off. She will just repeat her piece as is, finishing it off only by filling it in as much as she can.

Once our tiles are created, we marvel at each other's and can't wait to see them repeated. Luckily Julia has brought her laptop, scanner, and printer ("my portable office") to Rachael's so we can test the repeats. We scan in each of the designs, print multiple copies, and piece them together with tape.

As we pin all the designs to the wall we realize how satisfying it is to see them repeat so many times. We imagine what they could be used for. "Oh, I'd love yours on a tote bag." "That would be nice as sheets!" "I could see this one as curtains . . ." The wall seems pretty happy, full of color and shapes.

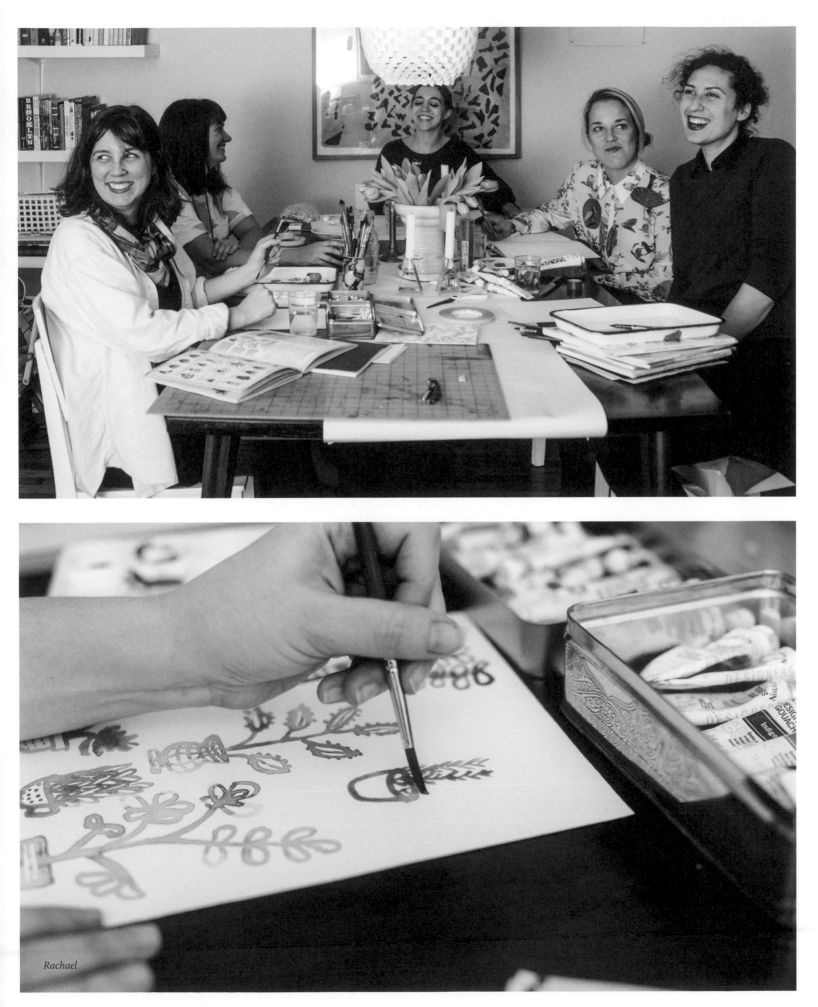

Rachael

> " I am drawing really fast in pen, so the mistakes are staying. When I start painting it, I have to make sure to color the right flowers so when it repeats they are the right colors.

JULIA

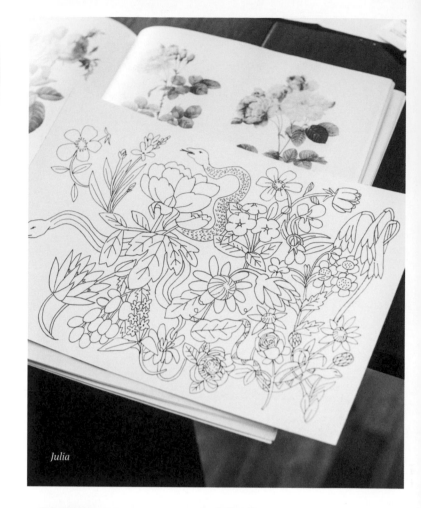

Julia

> " As my work has become more and more digital over the years, it's refreshing to have a good outlet to make things by hand again. There's something immensely satisfying and relaxing about how you're immediately connected to the thing you're making, as opposed to through a mouse and cursor.

LOTTA

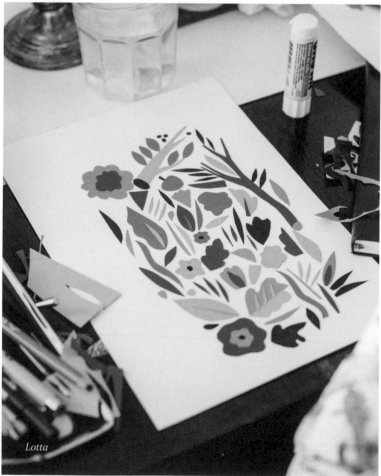

Lotta

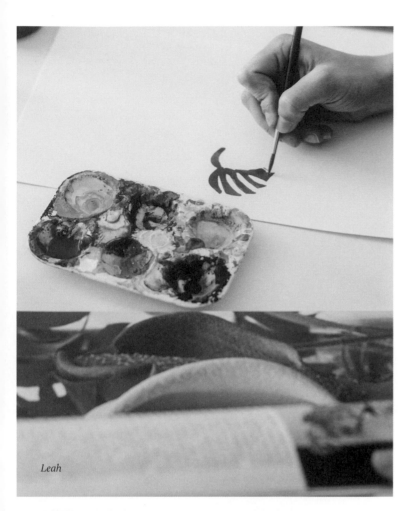

Leah

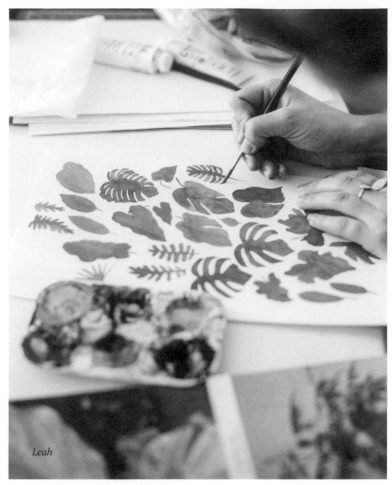

Leah

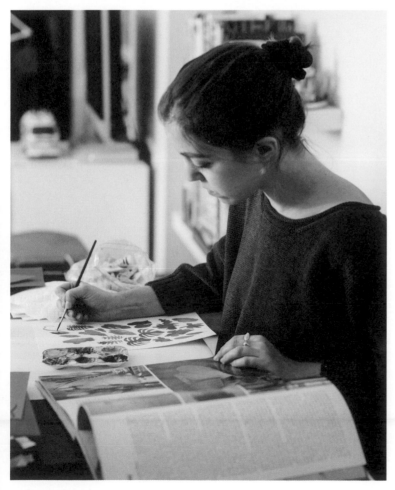

It's hard for me to contain my drawings in a box on a page. Making patterns allows me to feel unrestrained but also to turn my work into something tangible. It's so satisfying seeing patterns become real products.

LEAH

> "
>
> Watching other people work has always been one of the biggest inspirations for me, and this evening offered exactly that—I love seeing how different people approach the same brief from their own perspective. There's something freeing about getting back to a sort of 'school-like' environment: a bunch of people responding to the same brief and solving it differently.

LOTTA

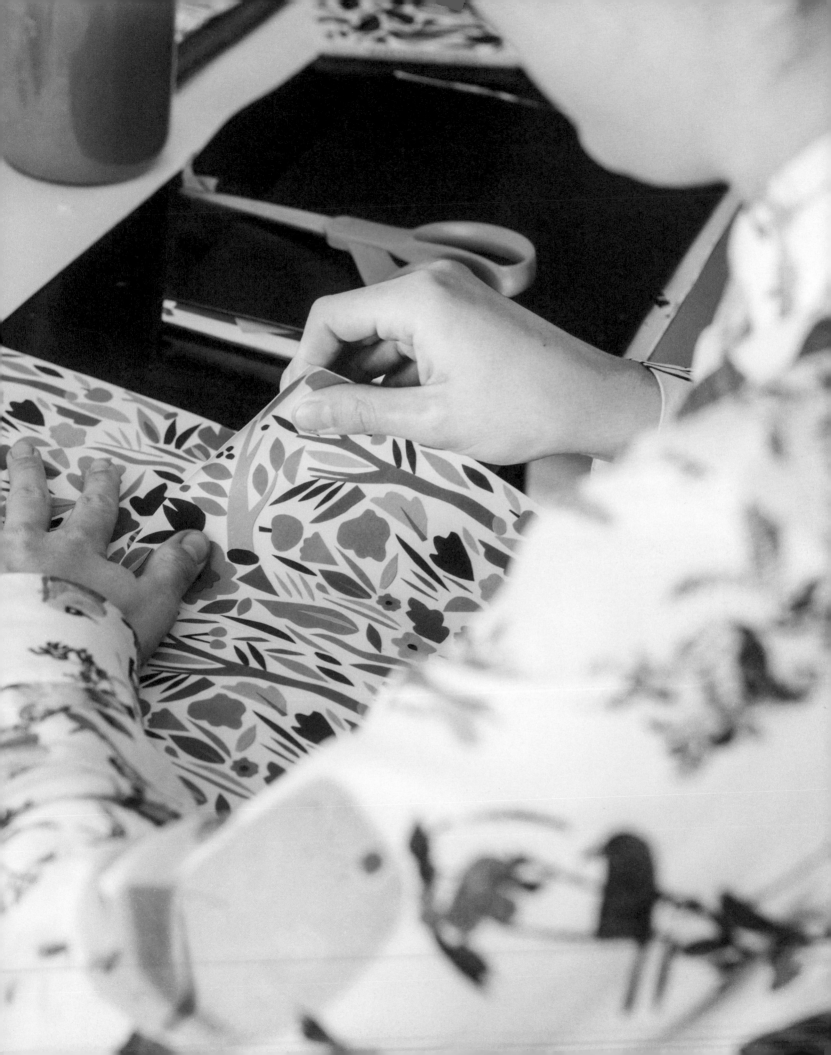

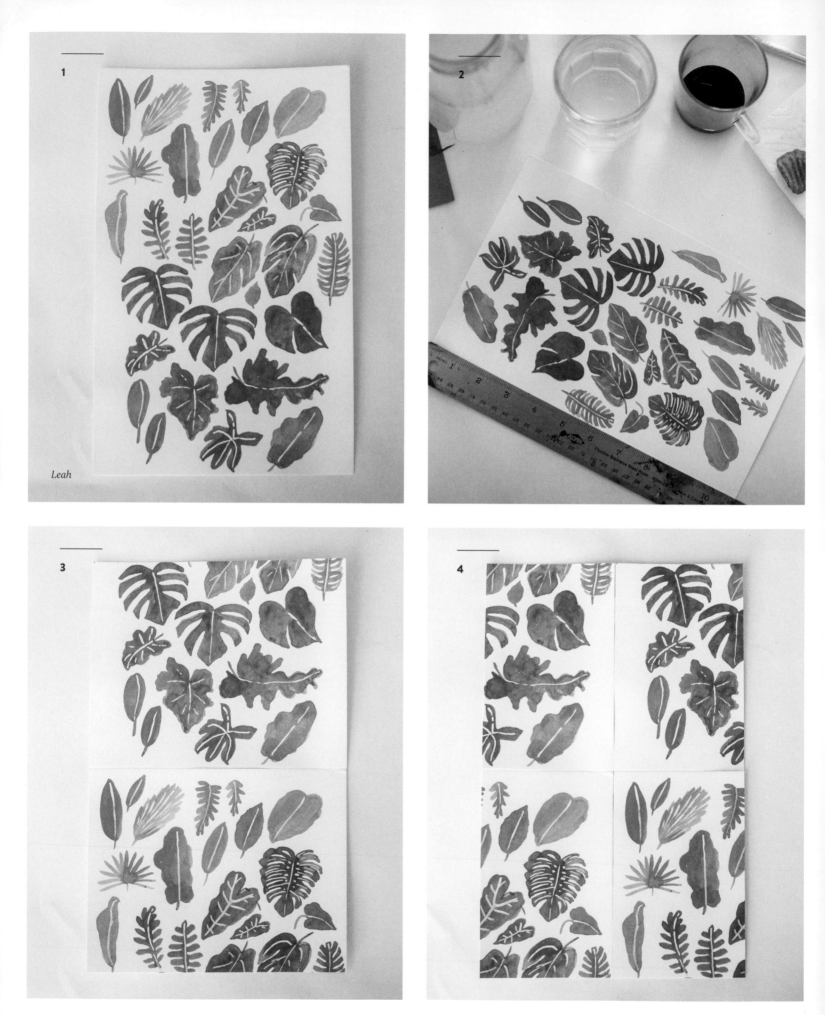

1

Leah

2

3

4

Pattern Play *Ladies Drawing Night*

HERE'S HOW YOU CAN DO IT

1 On a blank piece of paper draw a design in the middle of your paper without letting the drawing touch any of the edges. This is very important!

2 Once you finish the middle space as much as you want, you are going to cut your drawing in half horizontally—scary, we know!

3 Once you have the two pieces, swap them so the white edges meet in the middle and tape your drawing back together. Put the tape on the back of the paper so it doesn't obstruct your drawing. Also try to tape your drawing back together with the edges of the paper as perfectly lined up as possible.

4 Next you are going to cut your drawing in half again vertically (yikes!) and swap those pieces and tape them back together. Now your design should be on all the edges only and you should have a big white space in the center of the taped-together sheet.

5 Now fill this white space with the rest of your design. Remember: Do not draw to any of the new outer edges of the paper.

6 Once you finish filling in all the parts you want to fill in, you will have your repeatable tile. You could color this tile and then Xerox it many times and line up your design on whatever surface you please. Plaster it on your walls to make wallpaper!

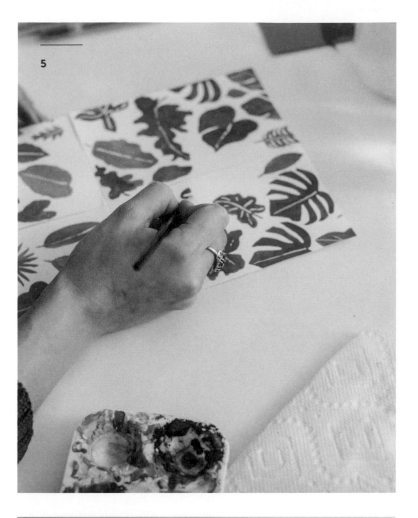

5

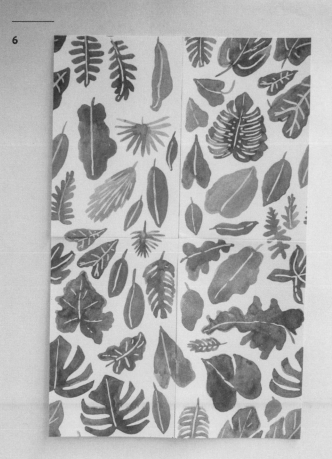

6

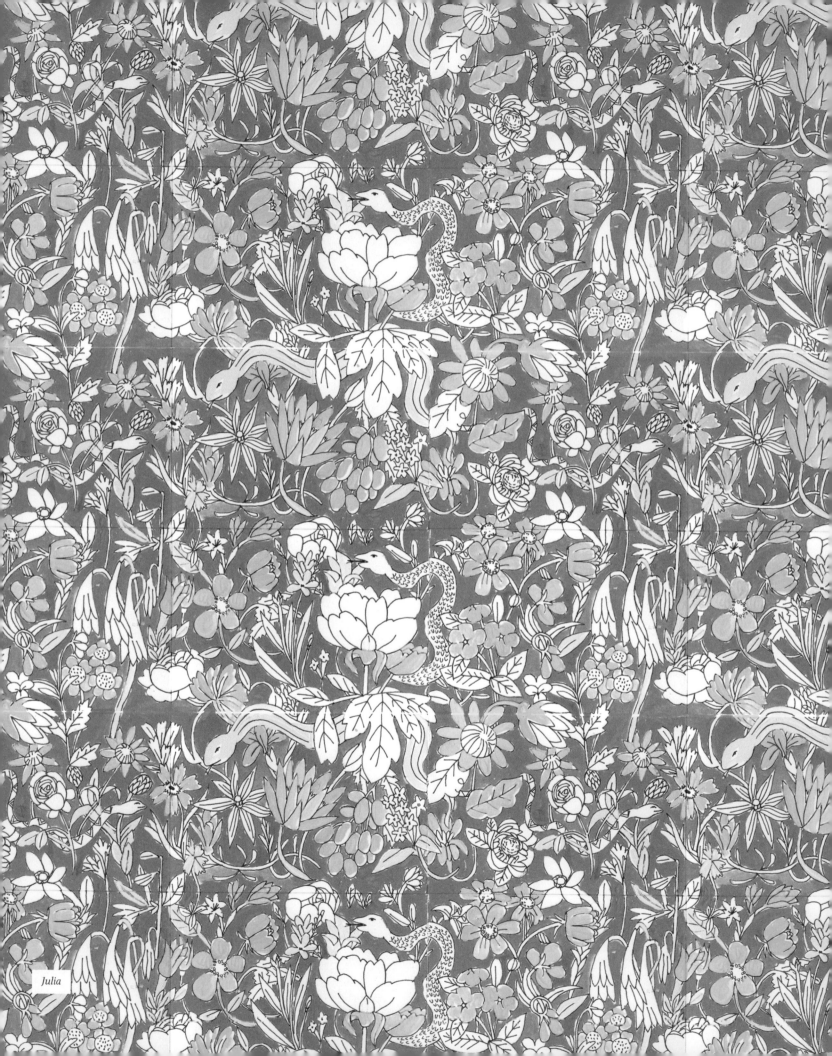

Julia

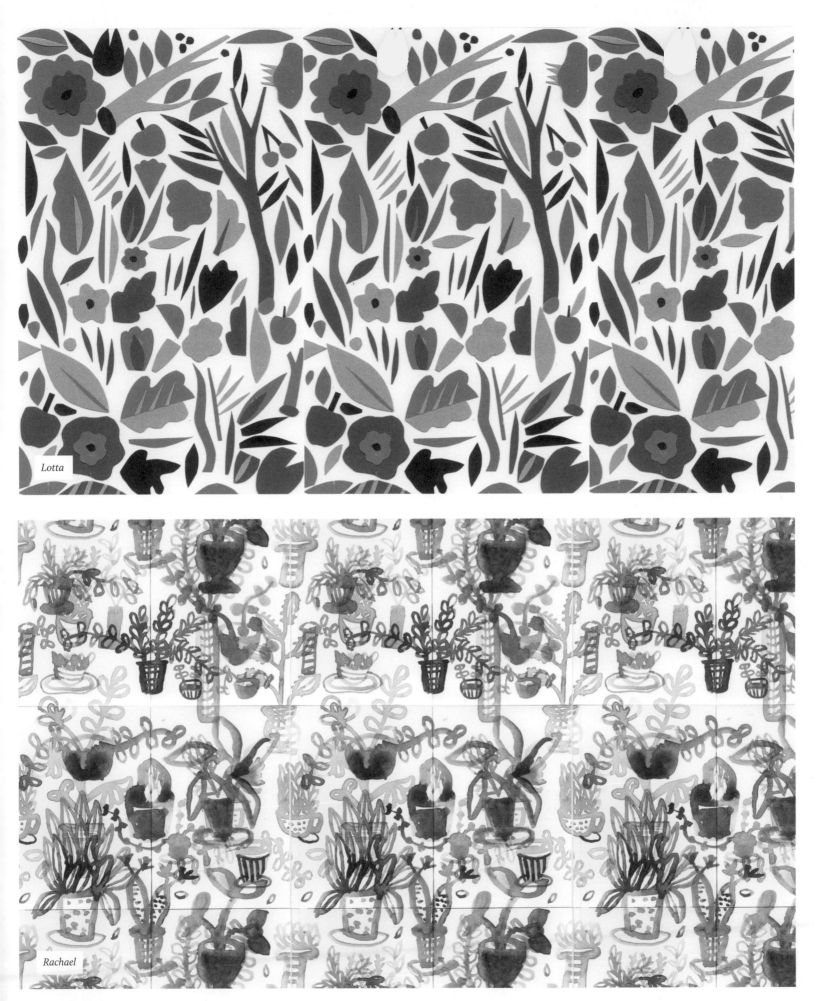

Lotta

Rachael

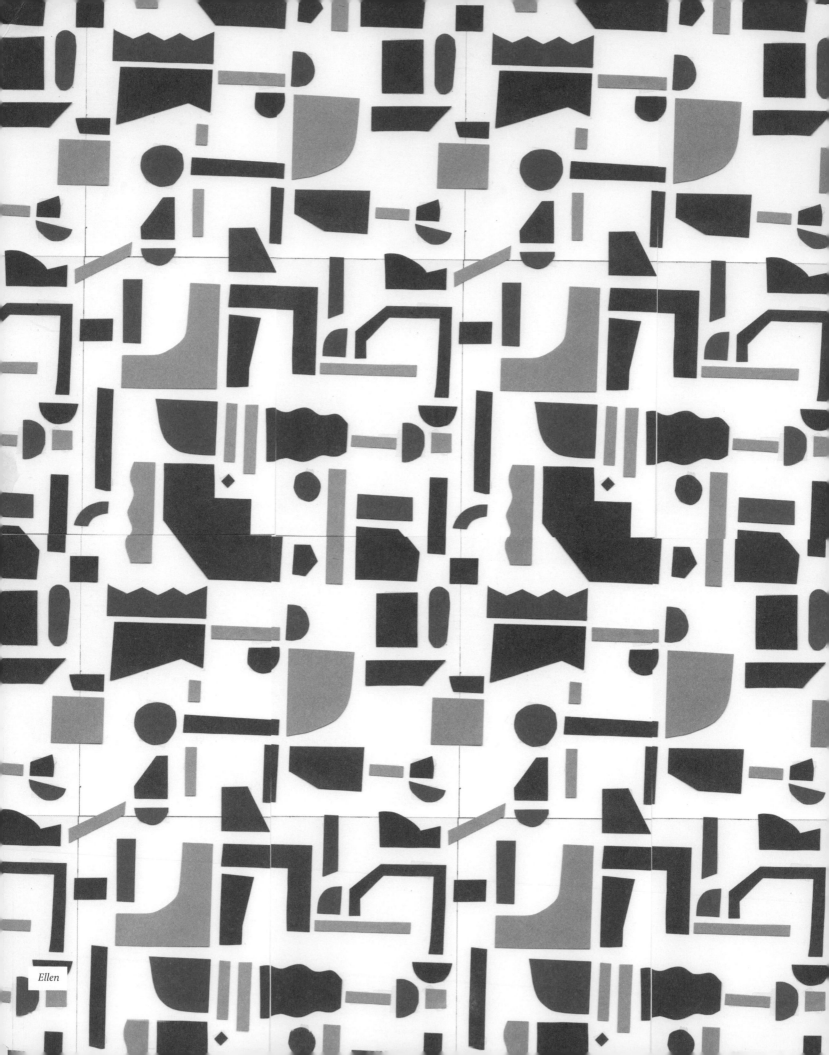

Ellen

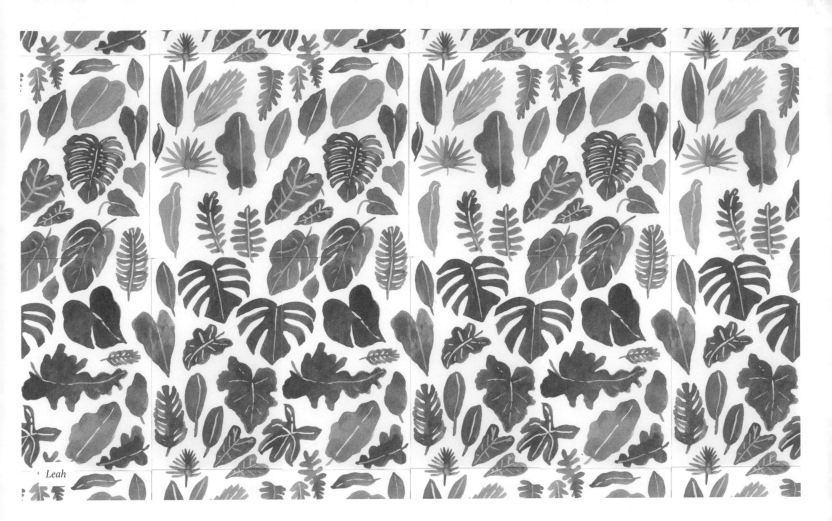

Leah

OUR TAKEAWAY

Even the simplest doodle can become a beautiful pattern. By rotating and repeating elements, textures and themes emerge in unexpected ways.

HERE'S WHAT WE USED

Everyone 8-by-10-inch scanner

Ellen Construction paper, double-sided tape, scissors

Lotta Fiskars scissors, UHU glue stick, miscellaneous colored paper

Leah Winsor & Newton gouache, Winsor & Newton Series 7 watercolor brush, Arches watercolor paper

Julia Uni-ball pen, Winsor & Newton gouache

Rachael Winsor & Newton gouache and watercolor, Arches watercolor paper, various watercolor brushes

Rachael

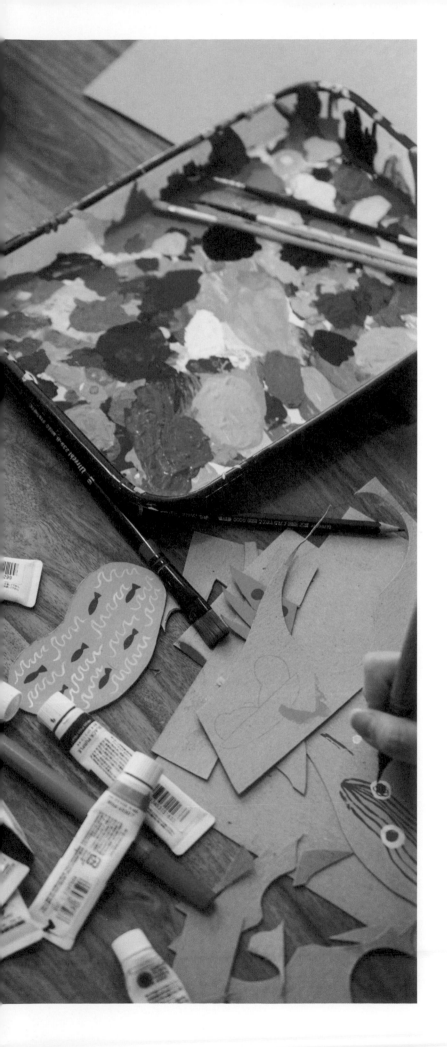

Cardboard City

with Kaye Blegvad and
Aya Kakeda

where Kaye's studio at the
Pencil Factory, in
Greenpoint, Brooklyn

After drawing so much on flat paper, it's time to get dimensional. We are moving beyond the page and exploring how our drawings can become 3-D objects. Inspired by theater sets, we're using a sturdy, noncorrugated cardboard, and cutting and painting it to form parts of city life: people, animals, plants, buildings, cars. The cardboard will stand up like facades, and the city will come alive.

Kaye Blegvad's studio is located in a large warehouse building in Greenpoint, Brooklyn, and shared with several other illustrators and designers. She offered up her workspace for the night, and we unloaded our cardboard, paints, and cutting tools onto the large communal table. Also joining us was Brooklyn-based illustrator Aya Kakeda.

KAYE is an avid constructor. Whether she's casting hand-carved wax pieces into brass and silver jewelry, hand-building a range of ceramics, or creating 3-D illustrated paper pieces, she is always pushing the boundaries of illustration. Kaye moved to Brooklyn after graduating from the University of Brighton in England, assuming that she would be a waitress since she had studied art. She never actually waitressed, though, and instead launched her wildly successful jewelry business, Datter Industries. Kaye also regularly takes illustration commissions.

AYA attended the Savannah College of Art and Design and then went to the School of Visual Arts for her master's. We knew she was more than qualified for this night based on her extensive experience with 3-D techniques. Aya has a history of collaborating with friends, creating dioramas in relief, and translating her illustration style into ceramics. She has also illustrated window displays for Macy's, designed toys for Giant Robot, and exhibited her work in galleries globally.

WE ARE BUILDING A CITY—painting images on cardboard and making them stand up, almost like facades. We limit the size of cardboard that we can use to 8½ by 11 inches so that all of our objects will be the same scale. After a bit of discussion, we also decide to limit the palette to oranges, reds, and pinks for cohesion.

There's always one person who has tons of supplies. Tonight that is Aya. She came prepared with dozens of acrylic gouache tubes, brushes, and scissors. We quickly get acquainted with all of these materials. Acrylic gouache is better than

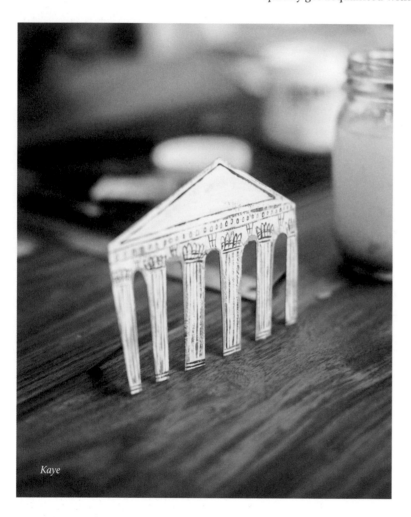

Kaye

water-based gouache because it offers more complete coverage over larger areas of the cardboard. The chalkiness is satisfying as well and is reminiscent of tempera paint from grade school, but the pigments are stronger and brighter. We experiment with using X-Actos and scissors. X-Actos are better for detail, but scissors are preferable for cutting out big shapes.

Rachael starts painting cars and Leah paints a tiny lady. We all look around to double-check at what scale people are painting, just to be sure the pieces will work together. Kaye whips out a columned structure in no time. Julia draws buildings from Amsterdam since she is about to go on a trip there, and Aya creates a building/woman hybrid first and quickly moves on to creatures in cars.

Since we want the cardboard images to stand up, we have to glue a triangular support to the back of each. This seems as though it would be simple, but in a few minutes Kaye is laughing at our toppling forms. We end up spending a lot of time getting this to work well, with Kaye coming to the rescue multiple times.

As we finish each piece, we arrange them into a group. Our city begins to take shape, and we fill in the gaps, deciding that we need to add a road, some trees, a fishpond, and flowers. Aya calls out, "We need some things that fly!" So to finish it off, we paint up some airplanes, clouds, and hot air balloons. With dental floss and a wooden dowel we find in the studio, we tie the flying objects so they can really "float" above the city.

The last thing we do is set up all of the pieces on a sheet of white paper so that we can take a finished photo. We can't believe how it all pulled together in the end. It isn't a polished set piece, but our little city is buzzing with activity.

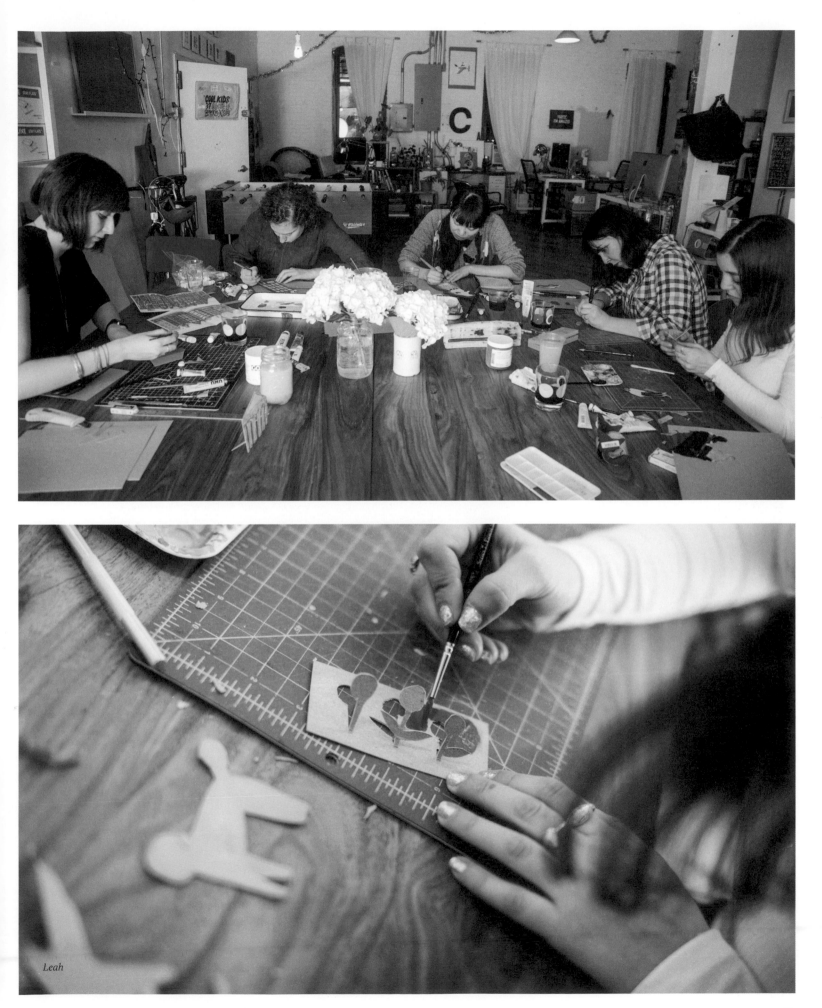

Leah

> "
> The support needs to be leaning back at an angle. With something bigger you need a sideways triangle, out of one long piece of folded cardboard.

KAYE

> "
> I always find it easy to visualize how things are going to fit together. Like when I sewed, I didn't need a pattern for making stuffed animals; I was always just a crafty kid.

KAYE

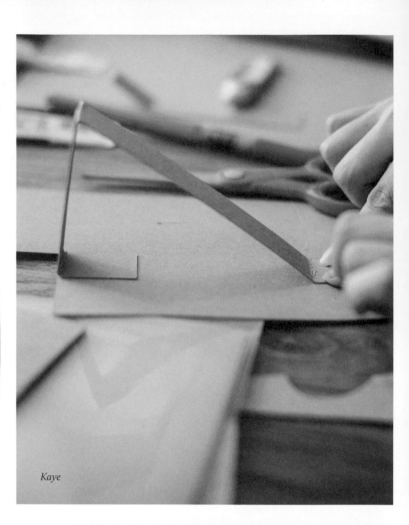

Kaye

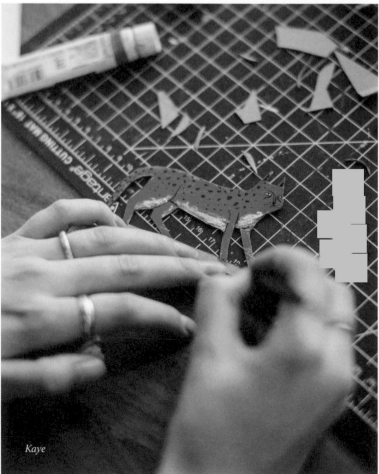

Kaye

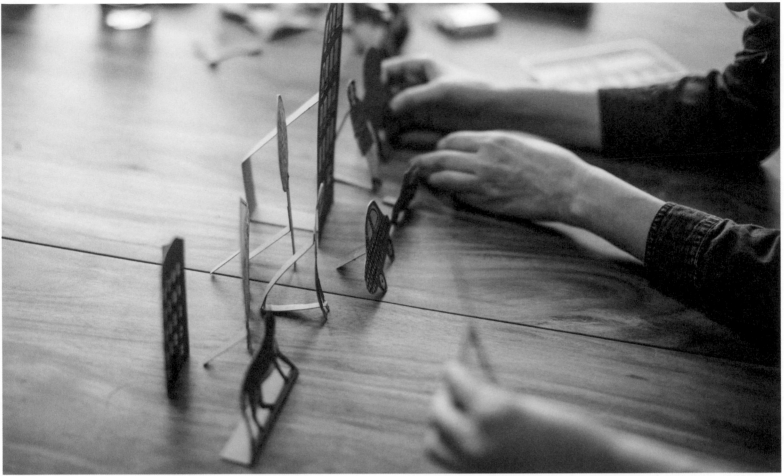

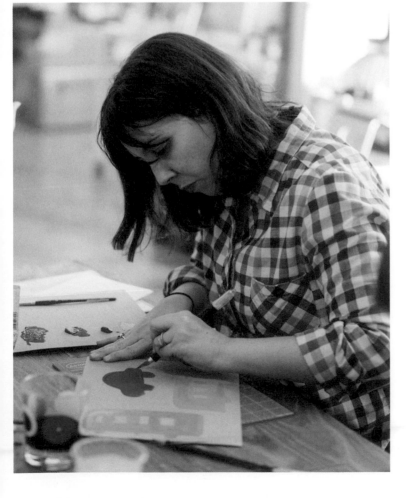

"
Making the stands was my least favorite part. Ha.

RACHAEL

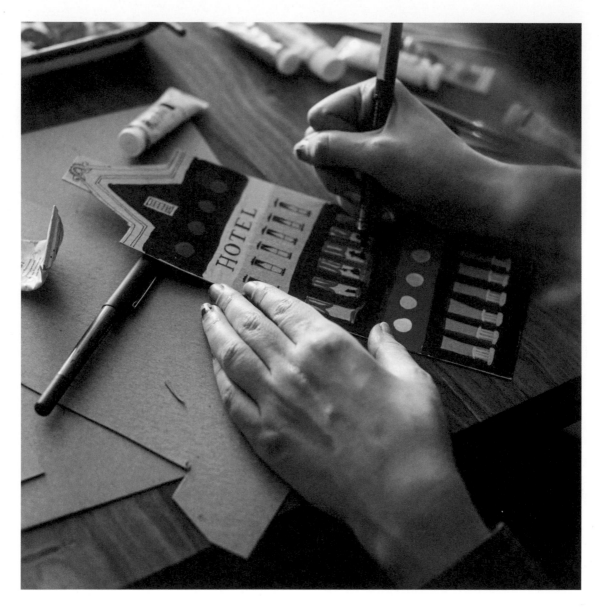

"

I'm having a good time imagining this is a real city.
What hotel would I want I want to stay in, and who
was inside each window?

JULIA

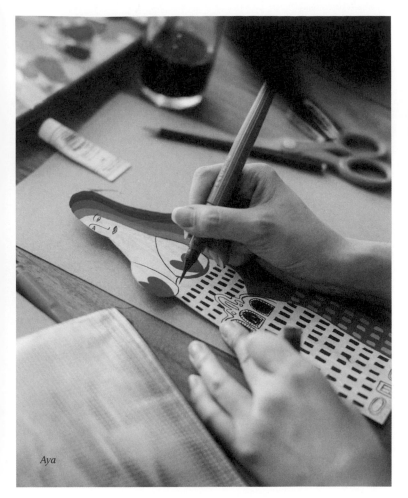

Aya

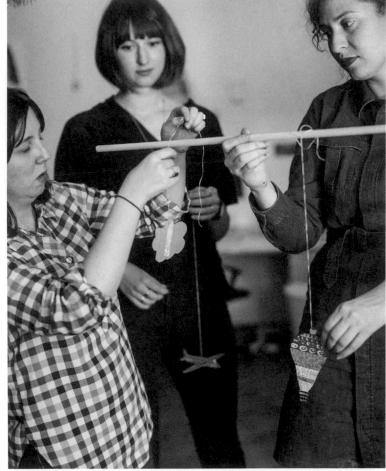

> "
> I had fun making buildings, which I don't usually do. I tend to create work that is in a forest or nature setting, but now I'm inspired to do some cityscapes.

AYA

> "
> I feel like I'm in a high school set design class.

RACHAEL

Rachael

> "
> This was hard! The cardboard was difficult for me to cut, and my X-Acto blades dulled quickly. It was worth it for the end result, though.

LEAH

Cardboard City *Ladies Drawing Night*

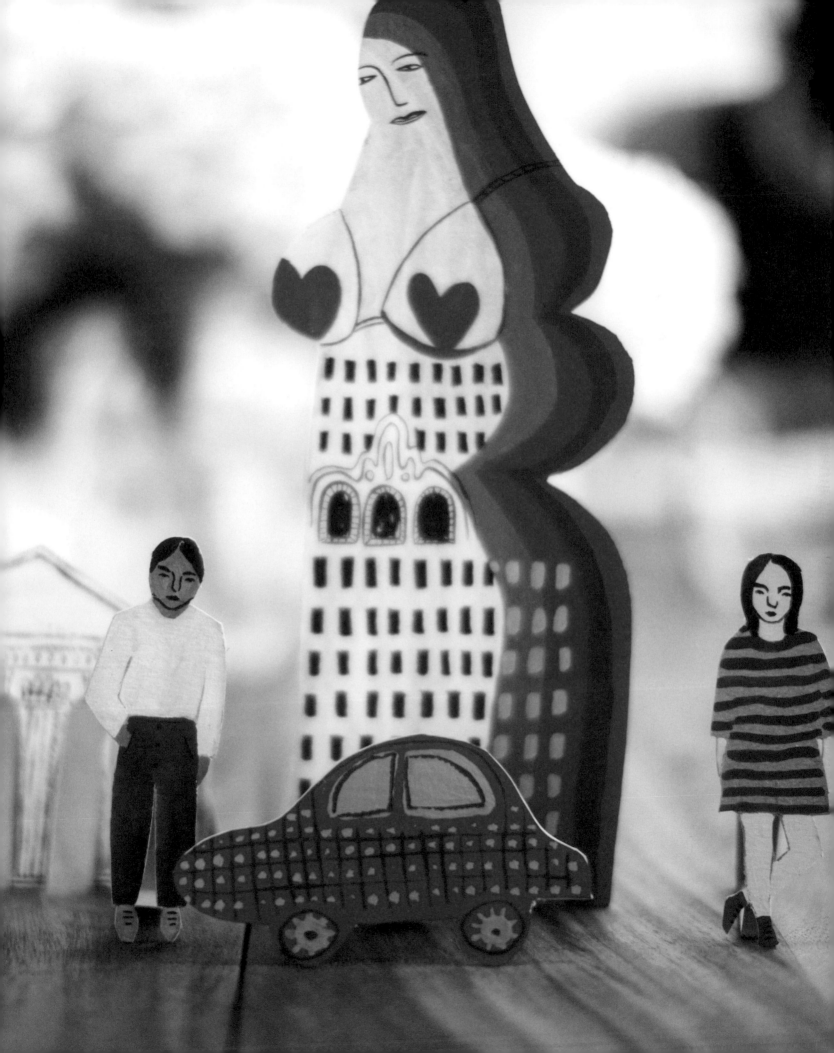

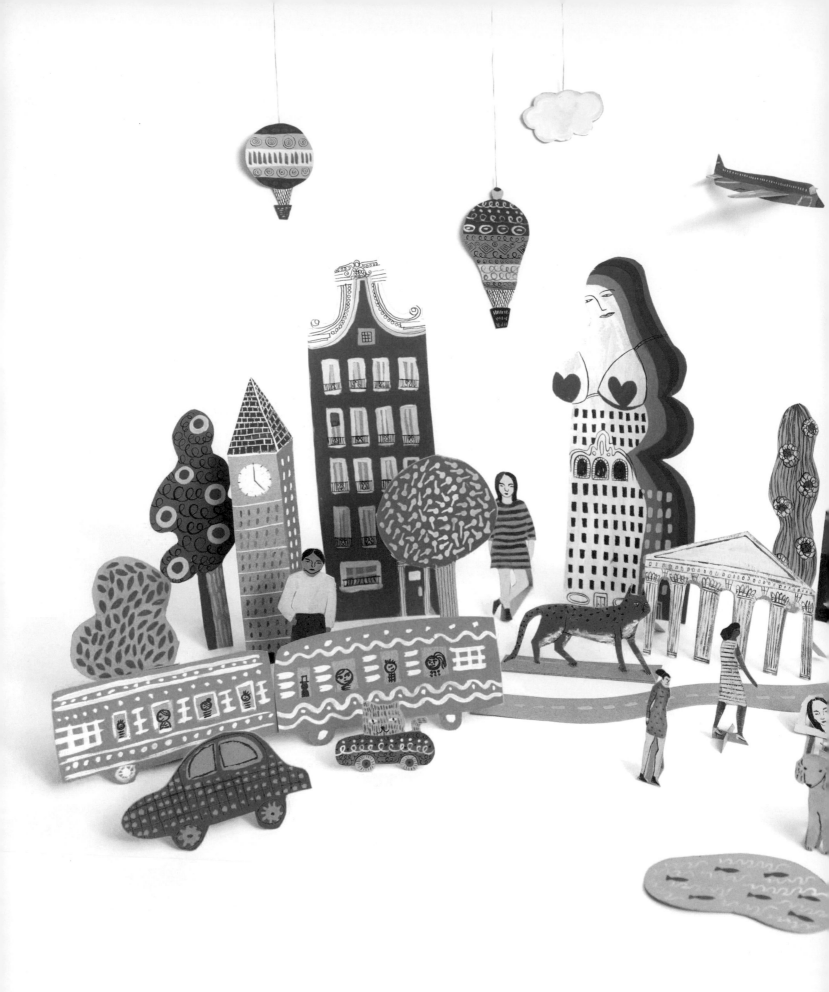

Bright pigments paired with the color of cardboard make for unexpected and welcome juxtapositions, and all of our pieces work together as a unit due to a few careful constraints.

HERE'S WHAT WE USED

8½-by-11-inch noncorrugated thin cardboard or cardstock, X-Acto knives, scissors, Holbein Acryla gouache, Pentel brush pens, Winsor & Newton gouache, UHU glue stick, string or floss, wooden dowel

HERE'S HOW YOU CAN DO IT

- Make your drawings directly on the cardboard. Try limiting your palette so that everyone's artwork looks as if it belongs together.

- Cut into your cardboard drawings using scissors or an X-Acto knife on a self-healing cutting mat. You can cut out a shape and then paint it, or you can cut it out after you paint it. You can also use cardboard as a cutting surface if you don't have a cutting mat, but it may dull your blade more quickly. Be careful not to press too hard and cut through the cardboard.

- Add supports to the artwork so that it can stand up. The bottom half of the triangle needs to be heavier than the top half of the triangle so that it doesn't fall over. You can also try using paper-doll-style supports, where you notch pieces of cardboard underneath the object so that the supporting piece of cardboard forms a cross with the object.

- Use a large neutral piece of paper as a backdrop so that you can take photos of your creation. Or take your objects out into the real world and try setting them in real nature and city environments.

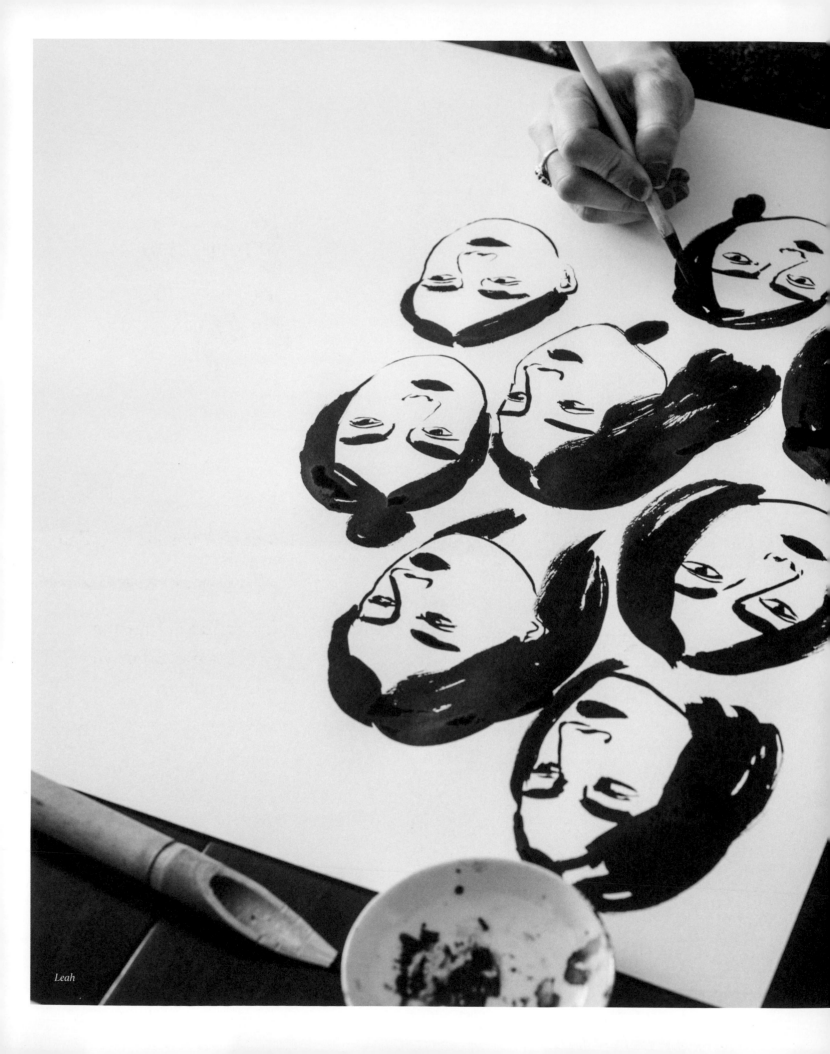

Leah

Going Big

with with Liz Libré and Ping Zhu

where Rachael's apartment in
Fort Greene, Brooklyn

Some artists make murals, others miniatures. Most of us are used to a regular letter-size sheet of paper; we are comforted by a size that feels in proportion to our hand and easy to control. With both apprehension and excitement, we decided to try something larger. We dipped our brushes in sumi ink and *went big*.

We scale everything up. Our paper size is 18 by 24 inches. All of the sheets lined up in front of us fill the entire tabletop with clean white. We still need more space, so we roll a set of flat files to the dining table as an extra surface. Guests Liz Libré and Ping Zhu have arrived and are ready to cover some ground.

LIZ is the owner of Linda & Harriett, a creative studio specializing in paper goods, homeware, and custom projects. Although many of her products are printed on a small scale, she starts with a much larger drawing, taping pieces of paper together when she realizes she needs more space. "I usually work alone. Ink, brush, repeat. And I use a lot of paper," Liz says. She went to Bates College, a small liberal arts school in Maine. After college, Liz had a random assortment of jobs: a slide clicker at a fancy art auction house, a high school lacrosse coach, and an assistant at a big ad agency. All the while, she made invitations on the side, an effort that eventually turned into Linda & Harriett.

PING is originally from Los Angeles, California, and now lives in Brooklyn. She studied illustration at the Art Center College of Design in Pasadena, California, and works as an editorial illustrator for clients including the *New York Times*, *The New Yorker*, and the *Wall Street Journal*. Ping works in gouache, and tends to paint small—usually on paper that will fit on a standard scanner. Her unique style of textured brushwork is full of life, though she describes her illustration process as "precise and premeditated." We are all curious to see how her drawing technique will translate to a big, inky page.

OUR BRUSHES ARE BIGGER, the bottles of sumi ink are huge, and we fill up large jars with water to dilute the ink and clean our brushes. We all use different reference material from various printed sources. Liz begins with a book of snakes, Leah finds images of bugs in books about printers' ornamentation, Rachael references a plant-care book that once belonged to her grandmother, and Julia starts by flipping through junk mail catalogs. Ping starts to work from her imagination but quickly switches to drawing all of us and our environment.

We are all a little uncomfortable at first, but everyone eventually finds her groove. Leah gets really into using a bamboo quill—a piece of bamboo with a sharpened point that gets dipped into ink. Rachael in particular craves going big, always feeling as if she is running out of space on her paper and pushing at the edges.

Ping reflects, "It's really satisfying to use something like this. I'm used to keeping things pretty precise and not having a fat brush that goes in all directions. It's nice to work with that instead of fighting it."

Julia feels a little exasperated with the sumi ink at first. "I have no idea what's going to happen with this ink. I'm just going with the flow. It pools here, it pools there."

Liz focuses on drawing the same type of imagery over and over, almost as a meditative exercise, by creating a series of large snakes. "They feel so much better together," she says, lining them up on the floor. By using a larger scale, she is able to add the markings of each particular snake in detail. Before long, Liz moves on to paint fish and seems quite used to working rapid-fire.

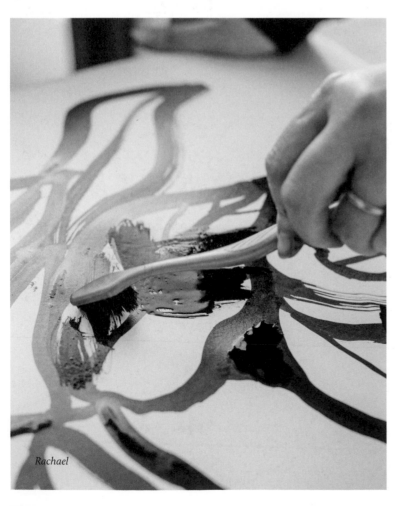

Rachael

Rachael and Leah discuss the unforgiving nature of ink, where there is no eraser and no delete key. "There are absolutely a bunch of accidents happening, so I'm trying to use the accidents, but I'm trying to not let the whole drawing be one big accident. I'm definitely walking the line as I move my brush right now," Rachael says.

Leah nods. "I think it can be hard to find the line between what's loose and still good-looking and just loose and bad."

As the evening progresses, we chat. Julia asks Ping about her trademark brushstrokes. Ping says, "I guess it's the nature of the paper with the brush together. I use BFK Rives paper, which is a print-making paper. It's really cottony and has tooth, so it really helps with dry brushing."

Our finished drawings fill the entire living room floor. We can't believe how much space we have managed to fill so quickly, and we spend a few minutes enjoying the enormous presence of the images. The payoff of the evening is—literally—large.

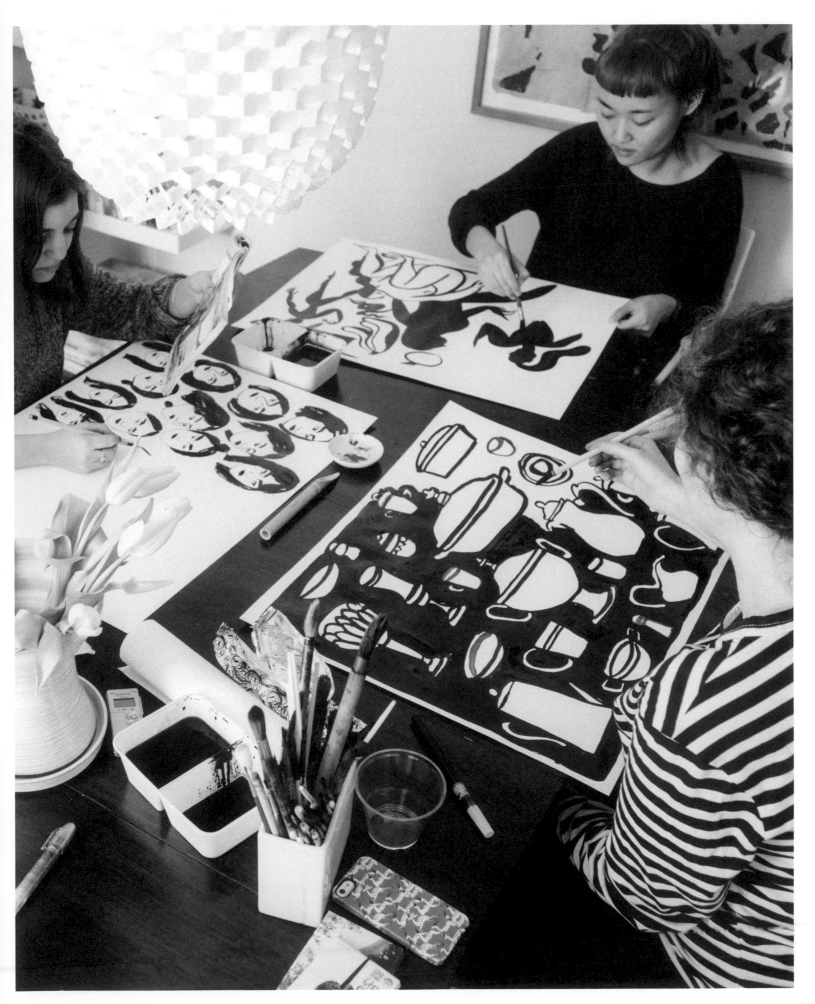

"

Sumi ink has more particles inside the wash than regular ink. It's more interesting, and I just like how dark it is, and it feels creamy and tactile. Sumi feels so organic and of the earth.

RACHAEL

"

This brush might be a little extreme.

RACHAEL

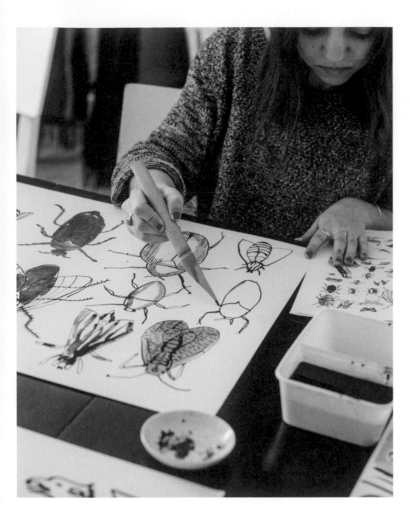

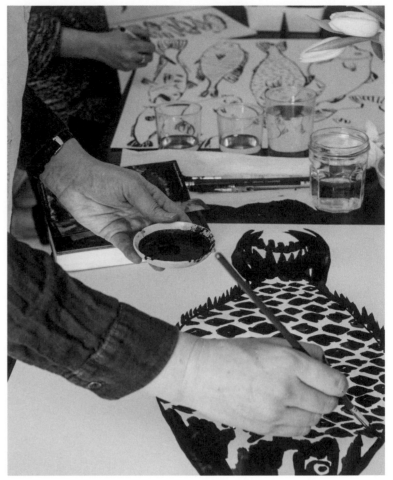

"

I remember using this type of quill in college and feeling loose and free. It goes places you can't control, but that's fun. I would never draw this big. I often feel cramped on the size paper that I use, but I'm a little freaked out by the large paper right now. Maybe I just need to warm up.

LEAH

"

I love the act of repeating the same thing. It feels so nice by the end. I get to know what I'm drawing really well. It's intimate.

LIZ

> "
>
> I like to do sketches in black and white even if it's for color assignments because it helps with values and making sure that my colors don't get muddy. When I sketch in black and white, I can lay down the darks and mediums and lights and just block them out from there. Black and white is easier for me to deal with than color, and color takes time. I sketch with line work, and then the shadows and values go on top.

PING

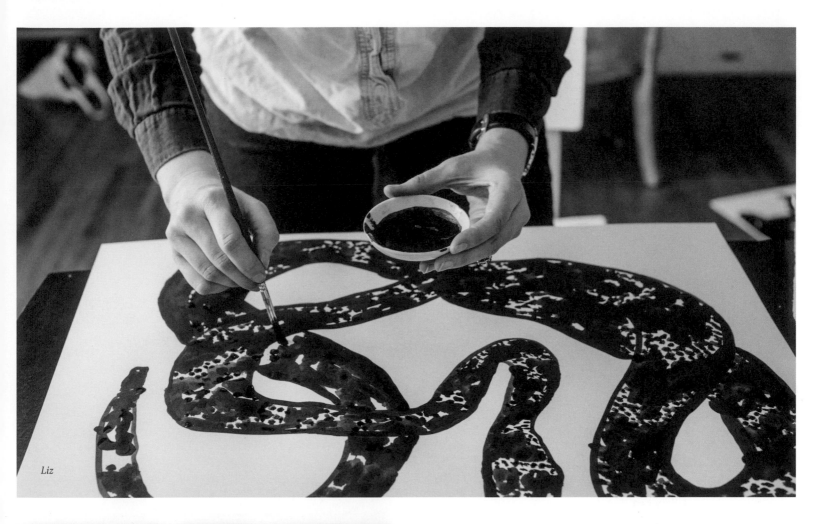

Liz

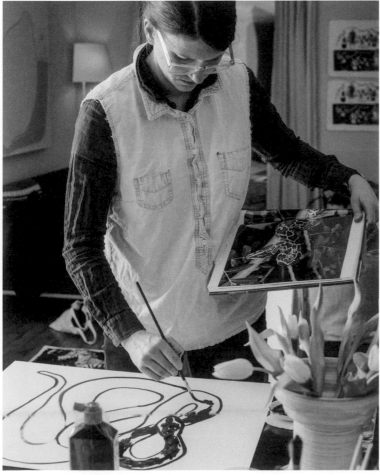

"

The evening was really eye-opening for me. I love doing things in life that are different from the normal day—things that are challenging and sometimes scary—like signing up for an Ironman when I didn't know how to swim, or going striped bass fishing in 40-degree weather when I know I get really seasick. But I don't always apply the same principle to my work, which—as I learned tonight—feels just as good and just as freeing. I usually work solo and was so nervous about the group setting, but I feel so full.

LIZ

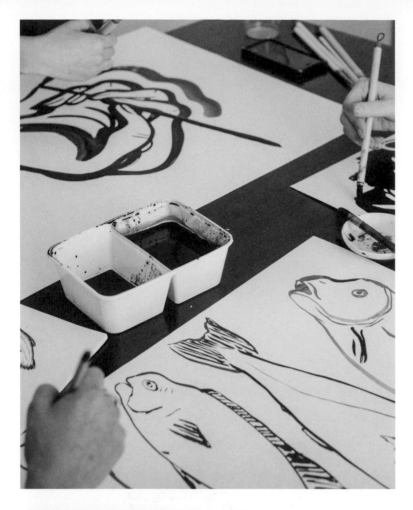

> "
> This is probably larger than I've ever worked. Even in school, it was oil or charcoal, but ink seems wild to work with at this scale.
>
> **PING**

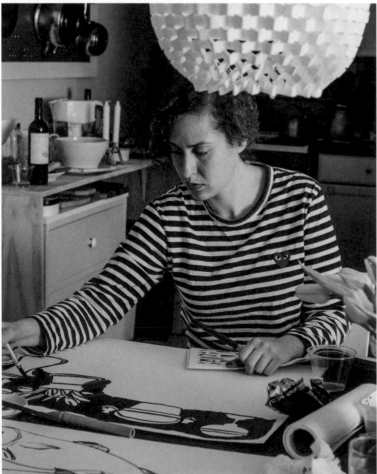

> "
> I hated what I was doing at first, drawing those ladies and trying to be detailed. But now I like my dishes drawing. Once I started drawing these big objects, I'm having such a better time. It's easier and looks better.
>
> **JULIA**

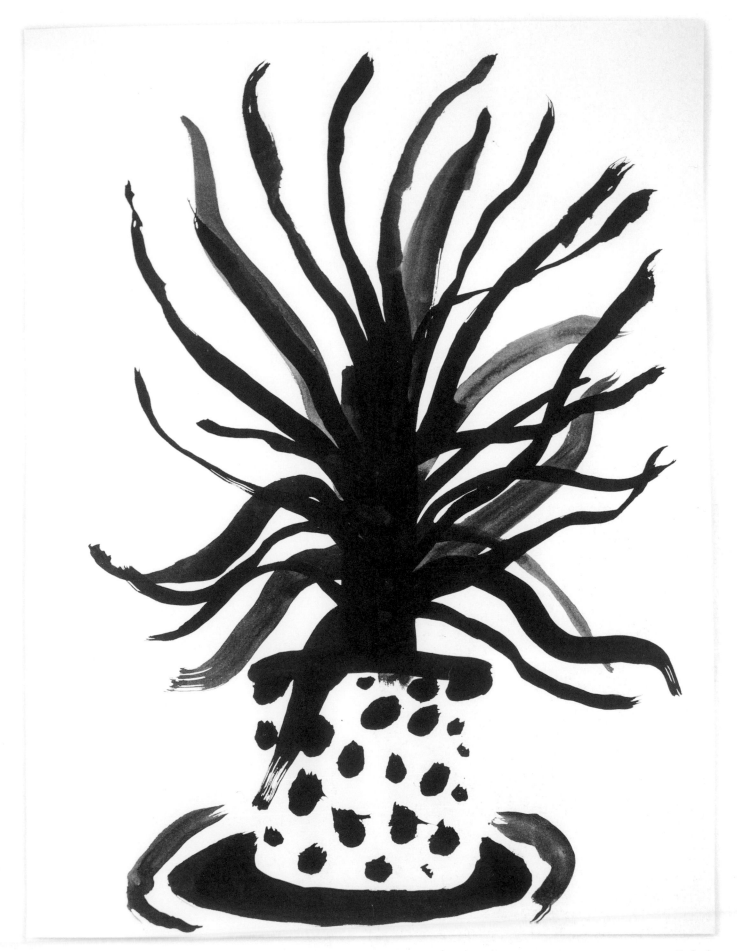

Rachael

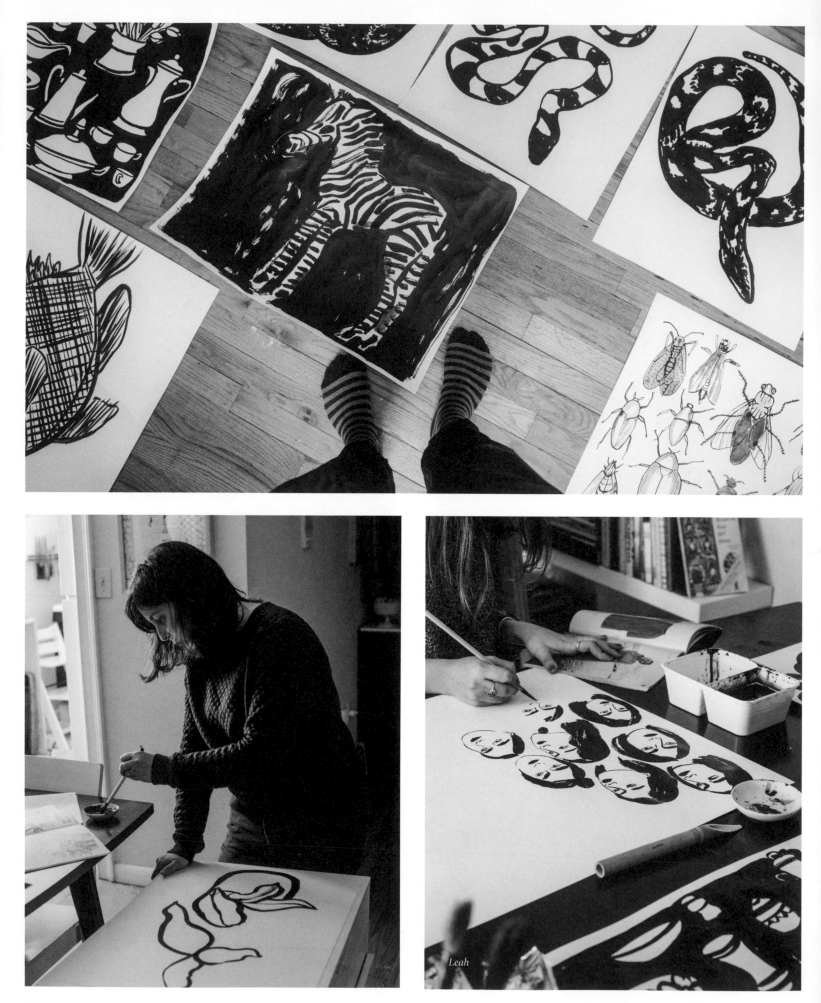

Leah

Going Big *Ladies Drawing Night*

Liz

Julia

Ping

Julia

Ping

Leah

Liz

Liz

Going Big *Ladies Drawing Night*

OUR TAKEAWAY

Black ink creates a bold statement. Even mundane objects like teacups or bugs look powerful when they are scaled up and in high contrast.

Rachael

HERE'S HOW YOU CAN DO IT

- Get heavyweight bristol board and black ink. We suggest sumi or India ink because you can get a lot of coverage very quickly, easily, and inexpensively on the paper. You can buy a few sumi brushes or use any medium to large cheap brushes. Just keep in mind that once you use a brush for sumi ink, you can't go back. Your brush will forever have particles of sumi ink in it. You can also try using other items to obtain interesting texture, such as toothbrushes or bamboo quills.

- Use a little caution with sumi ink. It's hard to clean up if it dries, but it's easy to clean up while wet, with a damp paper towel.

- Use reference or work from your imagination.

- Get loose! If this size is unfamiliar and uncomfortable for you, as it was for us, speed up your pace to fill the pages more quickly. If you "mess up," try to make it work, and if not, move on to the next drawing quickly. Try standing up so that you can move your arm in larger motions.

HERE'S WHAT WE USED

Everyone Sumi ink, sumi brushes, various watercolor brushes, bamboo quill, 18-by-24-inch bristol board, paper towels, wet cloths for clean up

Liz India ink

Rachael Old toothbrush

Rachael

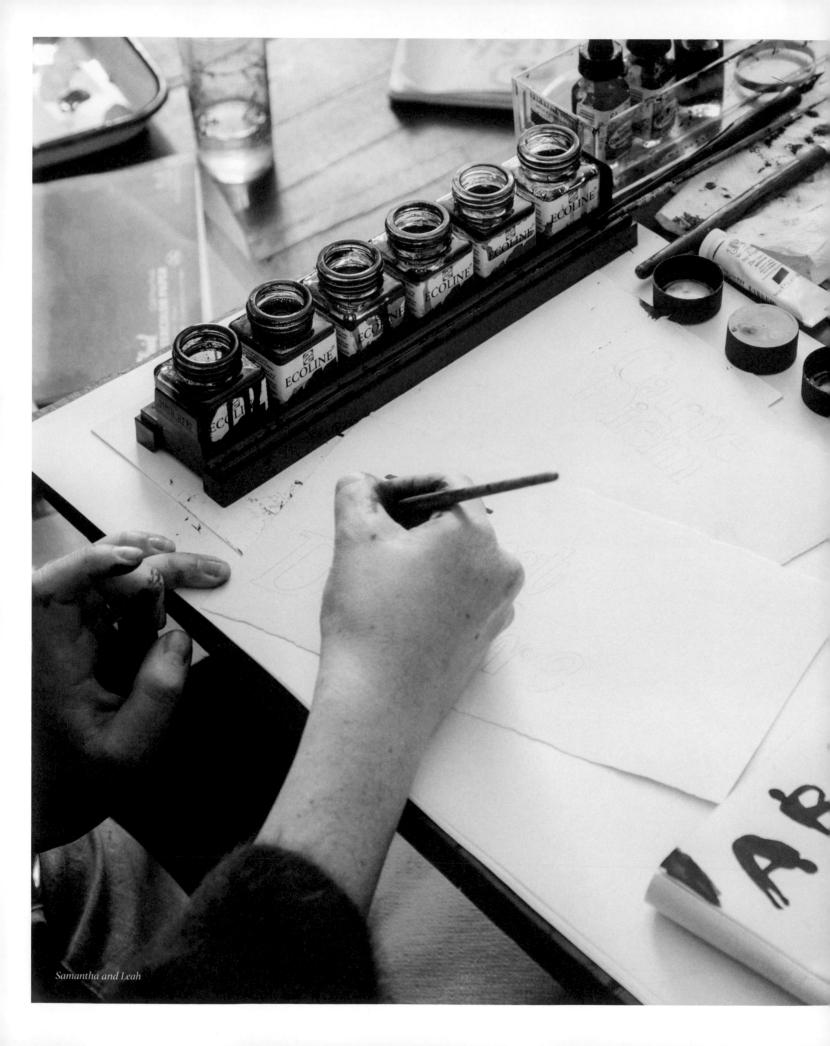

Samantha and Leah

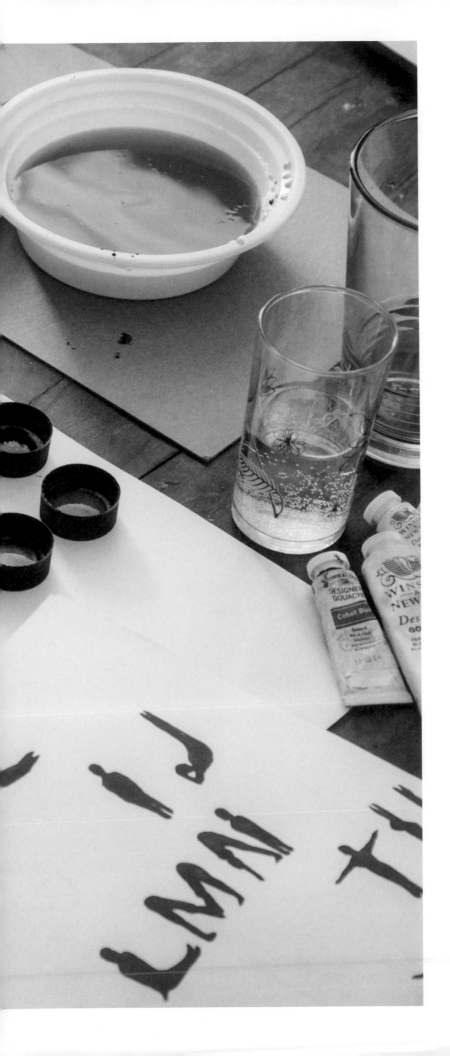

Spelling It Out

with Samantha Hahn and
Mary Kate McDevitt

where Julia's apartment in
Park Slope, Brooklyn

Just like any other art form, the way letters, words, and numbers look can convey a mood or meaning. Everyone has a handwriting style, and chances are it says something about you. Incorporating your handwriting into your artwork can add another layer of expressiveness. We're getting playful with letters tonight, exploring what forms they might take and how they can add to our work.

We meet on a chilly night to take on a task daunting to many illustrators: lettering. Leah has occasionally written out captions or headlines to accompany editorial pieces, Rachael has done some decorative lettering, and Julia has even created typefaces from her handwriting to use in her illustrated books. But we needed confidence to dive in, and so we recruited a couple of experts to guide us through the lesser-known world of hand-drawn type. Samantha Hahn and Mary Kate McDevitt join us to show us the ropes.

SAMANTHA is an illustrator known for her watercolors that often show off stylish women, fashion, and beauty. She has been commissioned to hand-letter cover lines for *Marie Claire* and *Vogue Nippon* and has lettered for her own books *Well-Read Women* and *A Mother Is a Story* as well as other books and paper products. Her lettering style is an extension of her illustration, full of inky scrawls and beautiful watercolor bleeds. "My mom was an illustrator," she said, "so I was drawing my whole life. I had an extra table that I used, and I always knew I wanted to be an artist."

MARY KATE is a letterer who specializes in illustrative type. Her work is full of bold colors and dynamic movement, often centered around an image or illustration. She explains to us how she fell into her style. "In college I studied design, but I was also doing illustration, and all of my projects had illustration in them. I was putting, like, Gill Sans on top of pictures and it looked really silly," she says. "So I just started drawing the type, and it made my projects look more cohesive."

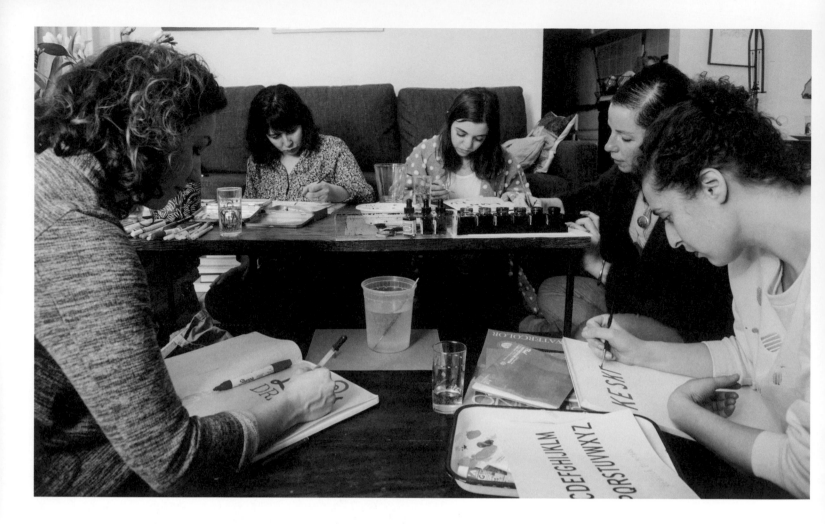

SAMANTHA BEGINS THE NIGHT equipped with pencil sketches, so she is ready to start on watercolor finals. "I'll erase the pencil line at the end," she says. "But I've mostly been getting hired to do more freehand, scrawly looking stuff, which I like better, actually." She explains she likes to figure out how projects come together as she goes, rather than planning exactly what the final will look like. For many of her freelance jobs, she draws words out many, many times, and then picks the best ones, or gives art directors a handful of options to choose from. Drawing the same thing repeatedly also allows for as many mistakes as she needs to make.

"I already have one mess-up," Rachael confesses.

"I'm glad that's allowed here," Samantha responds.

"Oh, that's the whole point," Rachael replies. "It's just to try stuff out of your comfort zone, and mess up."

"There are no rules," Leah adds.

Mary Kate brought her sketchbook and an assortment of supplies: acrylic paint, Sharpie paint markers, a charcoal pencil, and even gel pens. Like Samantha, Mary Kate begins with a pencil sketch, but their styles differ from there. Each word has its own character and individuality but comes together into one cohesive drawing.

Julia paints in gouache and covers a page in different phrases in various styles. It's just ten minutes into the night and she is pleasantly surprised: "You guys, I did good already! Pretty straight!" she exclaims. "But I should have kerned [adjusted the space between the letters] better. I need some space for my drop shadow. I'm doing Finnish words that say 'middle of nowhere.'" She explains her inspiration further. "I saw a lot of hand-painted signs when I was in Uganda and I wanted to do something that looked like that. They always do the 3-D lettering. But this is a Finnish saying, so it's a mix of cultures."

Leah takes a different approach, opting to paint an alphabet rather than think up words or sentences to write out. She usually paints completely freehand, with no sketch underneath, but she finds that when drawing letters it is easiest to start with a quick pencil sketch as a guide for shape and scale. Leah also decides to make her piece as illustrative as possible, building the letters out of little nude ladies. "It's easiest for me to think about letters as drawings and handle them in the same way," she explains. "Otherwise I become intimidated very quickly, because I know almost nothing about the rules of typography."

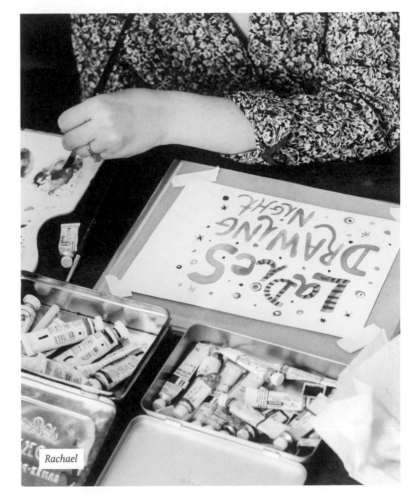

Rachael

Rachael draws out fluid watercolor words, decorating them with her signature grids, dots, and dashes. "As a novice letterer," she says, "it feels very different from making my other artwork because I have to really pay attention to whether you can read it and whether . . ." she trails off, lost in thought. "It's a different kind of harmony," she concludes. "I'm not sure I find it as satisfying, but maybe it's because I don't have as much experience with it." Even so, Rachael's pieces seem to have the most clear commercial use: A fancily painted "Thanks" could be printed right onto a card.

As the night grows later, we all begin to realize how much we accomplished. Samantha and Rachael covered dozens of sheets of paper with words, Julia filled a whole page in various styles, Mary Kate moved with ease through her sketchbook, and Leah started on her second alphabet. Once we had taken off, lettering wasn't so bad after all. And all of the problems—squished letters, smudged ink—just became funny. "The stress! The stress of lettering!" Rachael cries, and we all laugh.

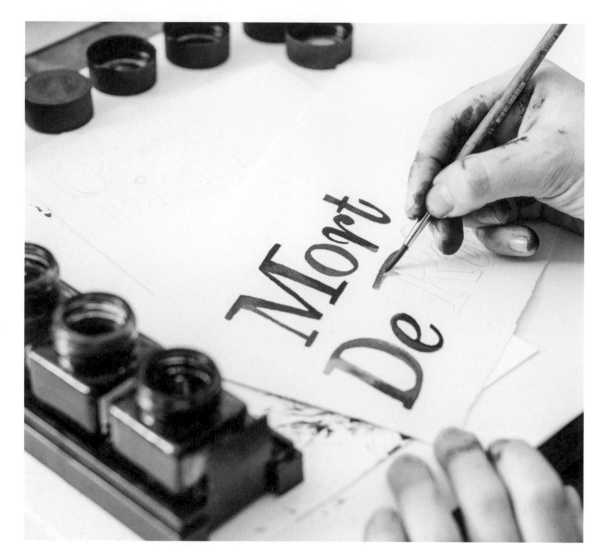

"

The lettering thing started as an accident, because
I actually have the worst handwriting! I get carded
at the bank because I can't do the same signature
each time, but thinking of the letters as art
somehow allows that part of my brain to kick in.

SAMANTHA

"

I learn more and more about [the rules of typography] all the time, because it is what I do, so it's hard to avoid it, but I guess the rules I follow are the ones that you just should follow anyway. If you're drawing a letterform that is unreadable, then that's when it becomes an issue.

MARY KATE

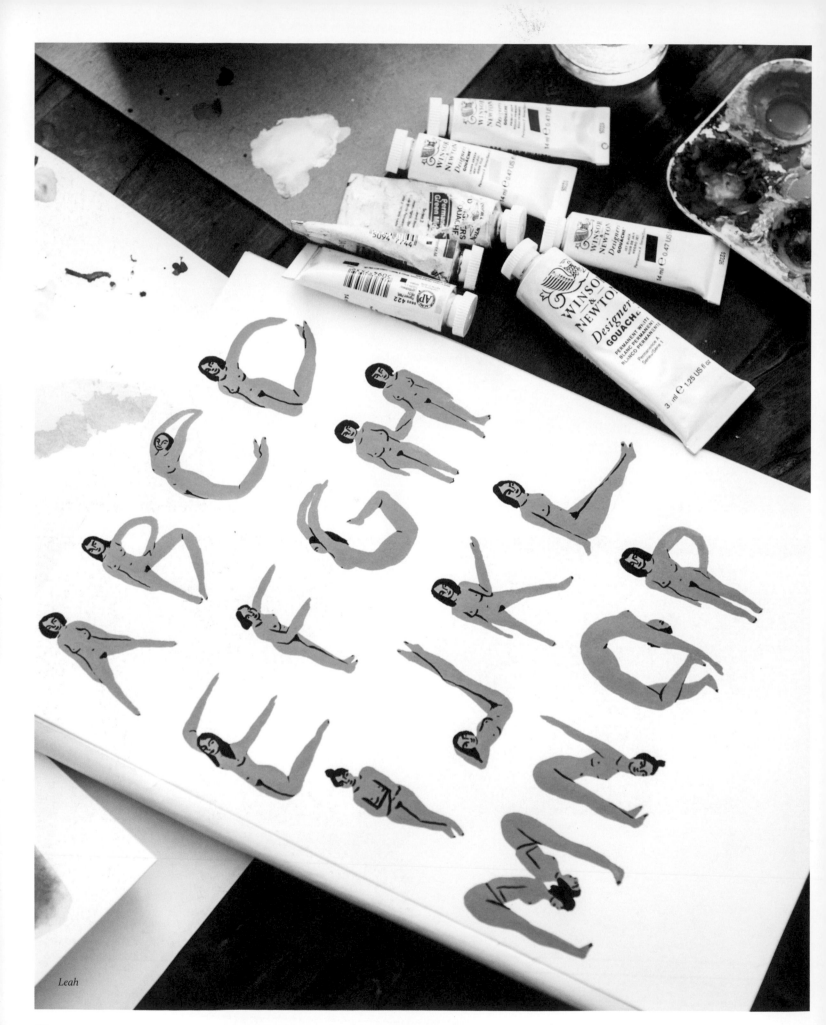

Leah

Spelling It Out *Ladies Drawing Night*

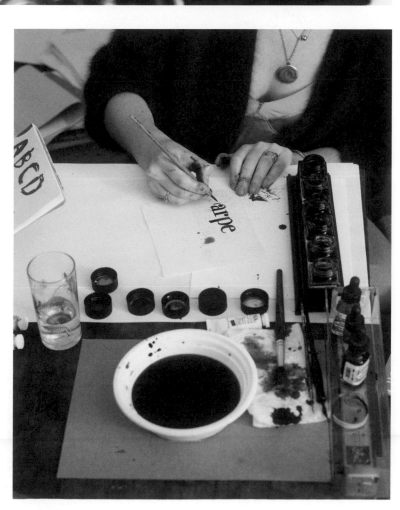

"

I always work like it's an emergency.

SAMANTHA

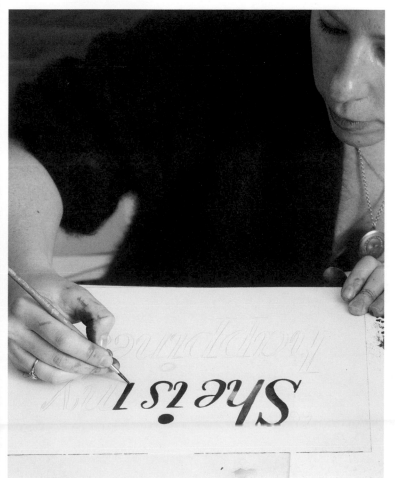

> "
>
> I used to, and I still do, use a lot of vintage advertising and lettering and reference material, but I'm trying not to reference that kind of thing as much so I can loosen up my lettering style. If I'm trying to follow all the typography rules for lettering, that's when it gets boring for me.
>
> **MARY KATE**

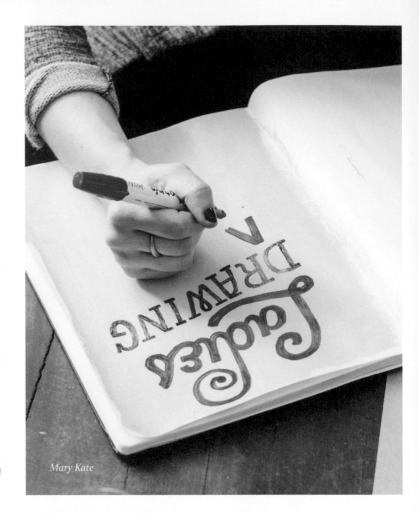

Mary Kate

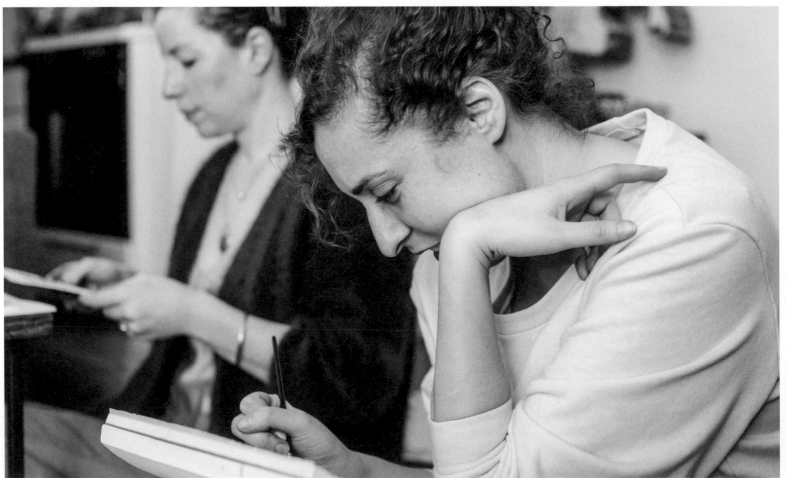

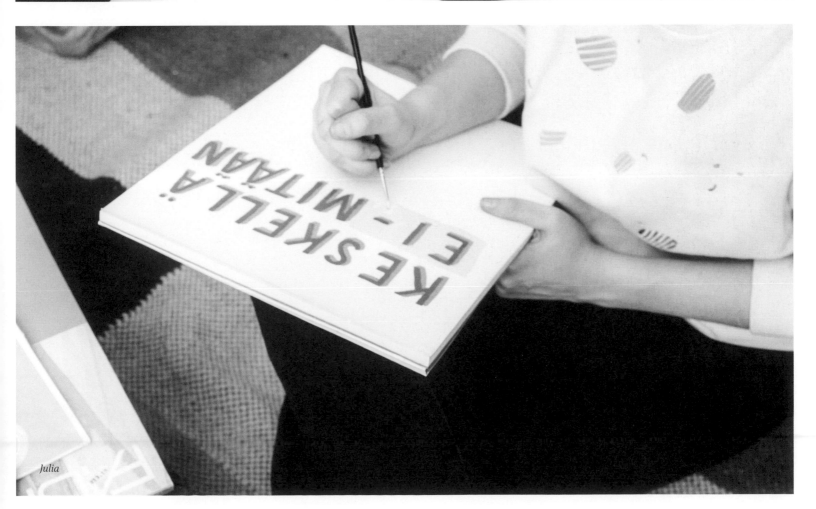

> I don't even know the rules, I just know what I think looks nice. Hand lettering is a sneaky way to do typography, because a designer can't look at it and say, 'She messed up the kerning big time.'

SAMANTHA

Julia

ABCDE
FGHIJ
KLMNO
PQRSTU
VWXYZ

Leah

KESKELLÄ
EI - MITÄÄN
8⊙
Ladies
Drawing
Night
R. M
V

Julia

Ladies' DRAWING NIGHT

Mary Kate

The BIG Emerald COUCH

Mary Kate

"She is my happiness"

— NATHANIEL HAWTHORNE

LADIES Drawing Night

Samantha

OUR TAKEAWAY

Letters are pictures, too!

HERE'S HOW YOU CAN DO IT

- Write your name in every medium you possibly can. Imagine your letters as shapes, not as letters.

- Try out some numbers, too. It takes the letters out of it!

- Copy or trace a font you like. Your version will come out handmade-looking, but it will help to provide you with a structure.

- Write a phrase, poem, or saying you like. Think about how it is composed on the page.

HERE'S WHAT WE USED

Mary Kate Acrylic, gel pens, Sharpie paint markers, charcoal pencil, sketchbook

Samantha Ecoline liquid watercolors with quill and brush, felt-tip pen, Micron pen, vintage/salvaged paper, Canson drawing paper, Arches watercolor paper

Leah Winsor & Newton gouache, Winsor & Newton Series 7 watercolor brush, Kunst & Papier soft cover sketchbook

Julia Uni-ball pen, Winsor & Newton gouache, heavyweight bristol board

Rachael Winsor & Newton gouache and watercolor, Arches 90-pound hot-press watercolor paper, various brushes

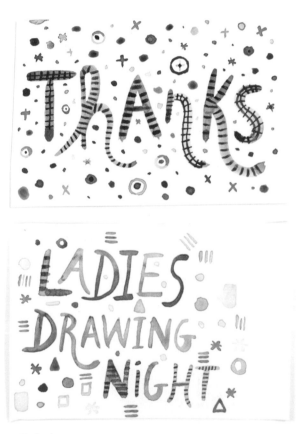

Rachael

Samantha

115

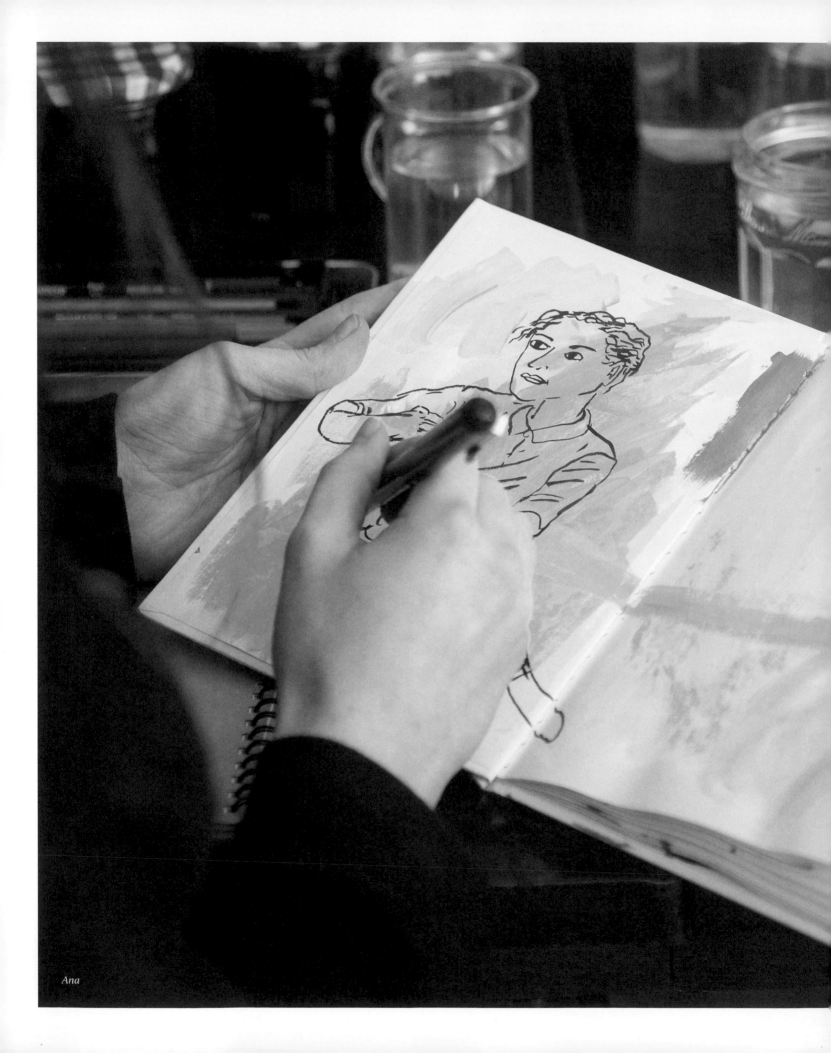

Ana

Strike a Pose

with Andrea Pippins and
Ana Benaroya

where Rachael's apartment
in Fort Greene, Brooklyn

Figure drawing.

It feels like the oldest exercise in the book, from figures depicted in prehistoric art to the six-hour-long required drawing class in the first year of art school. And still, we love to do it and find something new to see in the form and movement of the body.

For figure drawing night, we are lucky enough to have Andrea Pippins join us from her home in Baltimore, Maryland. Artist and illustrator Ana Benaroya also comes by, sketchbook in hand. Ana confesses she hasn't drawn from life in a while, maybe even since her freshman year in college, save for a couple of more recent events. "I rarely draw from life," she says. "I got in the habit of drawing from my imagination."

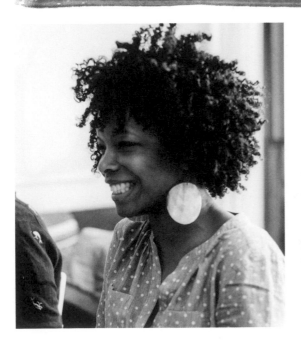

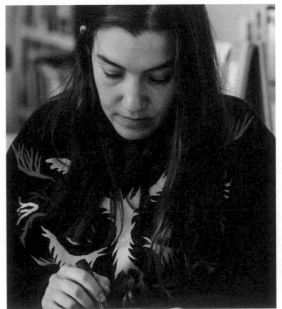

ANDREA works as a designer and educator, teaching graphic design at the Maryland Institute College of Art. Her background includes a BFA in graphic design, and an MFA from the Tyler School of Art at Temple University. Her work is bright and graphic, filled with patterns, lettering, and portraits of strong female leads. She is the author of *I Love My Hair: A Coloring Book of Braids, Coils, and Doodle Dos*, a beautiful and intricate adult coloring book celebrating diverse hairstyles.

ANA is an illustrator, artist, typographer, and designer who graduated from the Maryland Institute College of Art. Her drawings are loud and colorful, full of characters and a bold sense of humor. She draws bulging musclemen, women covered in eyes or gaping mouths, snarky cats, and hairy pigs—things you would rarely encounter in real life. Ana had prepped for the night by covering blank pages in her sketchbook with multicolored paint strokes to create interesting surfaces to draw on.

WE DECIDE TO TAKE TURNS posing for each other, settling on ten-minute poses—short enough that we won't get too tired of holding still, and long enough to focus on the details of the drawing. While we all feel awkward at first while modeling, we soon warm up to being the center of attention.

"I don't think I've ever sat for a portrait," Andrea notes.

"How does it feel?" asks Julia.

"Intense!" she replies, and we all laugh.

It *is* intense, but it is also relaxing to sit back and wait to see how your friends' brushes and pens interpret you. "You're so pretty!" we keep exclaiming over and over. "Everybody is pretty when you start looking at them," adds Julia.

Rachael continues, "One thing I love about drawing is the world looks so much more interesting after you draw. You see better afterward."

As we draw, we begin to notice lines and shapes the eye wouldn't usually pick up on, and we add these details to our drawings. The curve of a lip, the shape of a hairdo—these things add character and likeness to the figure.

"Usually when you start, you go loose, crazy," says Julia, recalling the quick poses that usually kick off a figure-drawing session. "I can't remember how to do that!"

A few portraits in, we begin to remember how to loosen up. While we each sit stoically in a chair for the first round, we decide to strike wilder poses for the second. Julia lounges, her arm draped over her head; Andrea stoops down, her head resting on a fist; Rachael and Leah stand on the chair, stretching out as if leaping right off of it.

As the poses become more dynamic, so do the drawings. Rachael draws larger, filling the page with inky strokes. Leah pares down what she was doing before, focusing on wobbly contours instead of solid shapes. She also allows the poses to overlap across one sketchbook spread, instead of treating them like individual drawings. Andrea and Julia draw in pen, sweeping their hands across the paper to create quick and confident lines. Ana gets out a black china marker, building up strokes into an energetic scrawl. The resulting drawings have an emotion and energy that the sitting portraits, though beautiful, lacked.

After taking turns posing for a few rounds, the time flies by and the night grows late before we know it.

Andrea

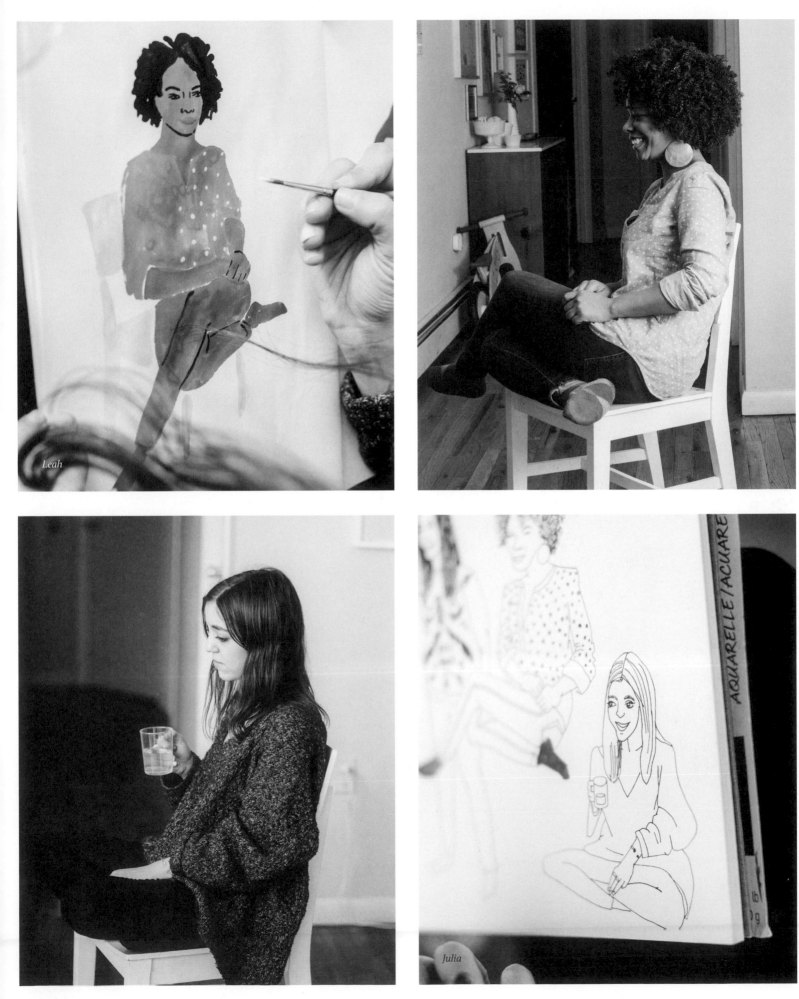

Leah

Julia

"
I prefer to focus on portraits
rather than full figure drawings.
I can get lost in a face.

RACHAEL

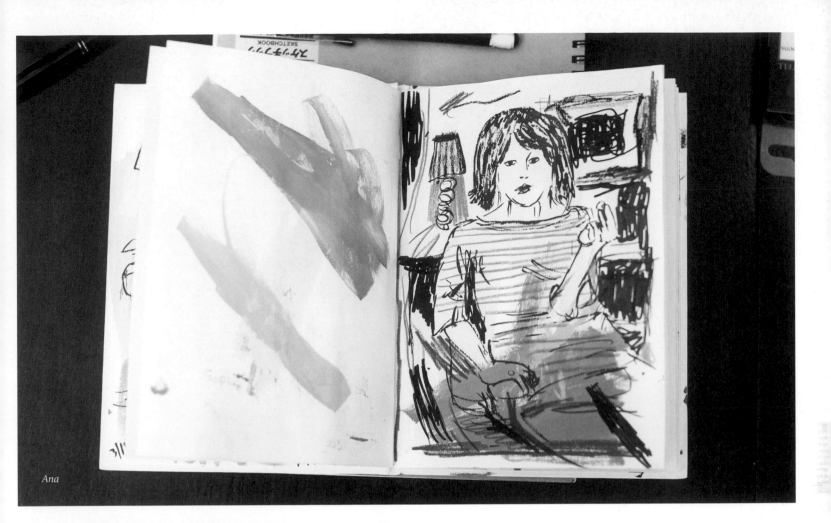

Ana

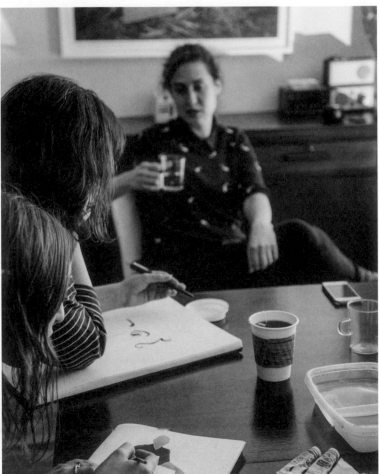

I came with my sketchbook pages prepainted with abstract backgrounds. This way I didn't have to start with a boring white page. I also think this helped me have more fun while drawing each pose. The page was already messy and playful, so it gave me permission to keep my drawings messy and playful.

ANA

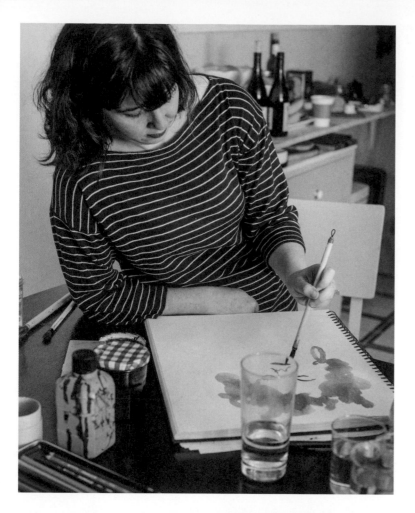

Don't you think people always draw some of themselves in their drawings? It's the same thing as how people look like their pets—they look like their artwork.

RACHAEL

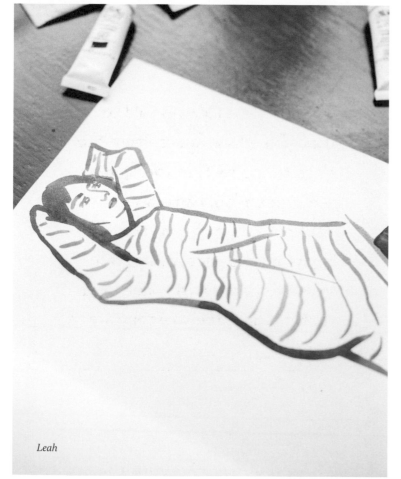

Leah

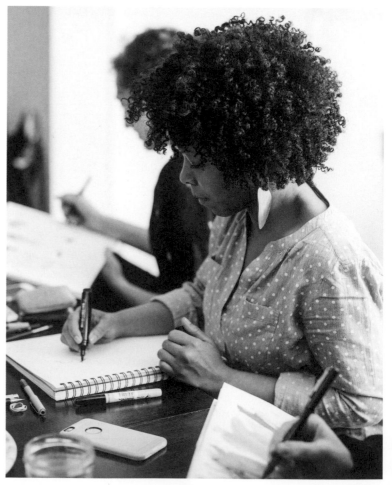

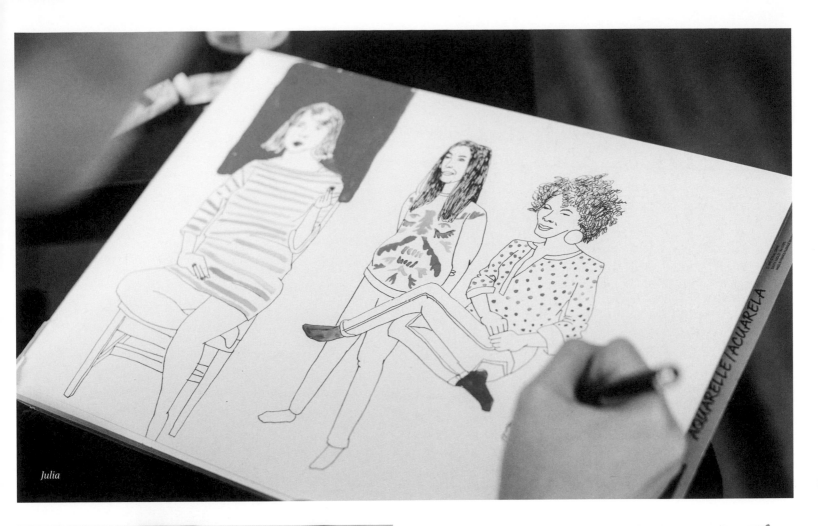

Julia

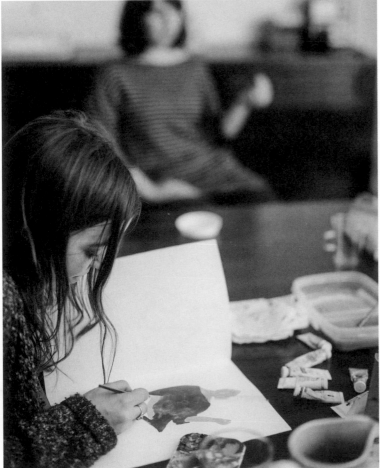

> "
>
> In school I was always told to draw the entire figure, from the head to the feet, so the figure feels grounded. I am always cautious now of fitting the figure on the page, getting all parts of them on the paper and making them feel like they are in a space.

JULIA

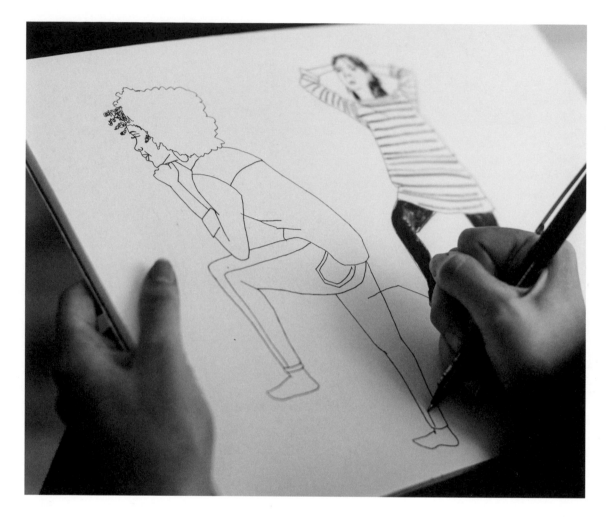

"

I know that the proportions of my drawings are wrong. It makes the people look more interesting, though. Since I am only using pen, I have to just use whatever line I make. Long leg or giant head, oh well.

JULIA

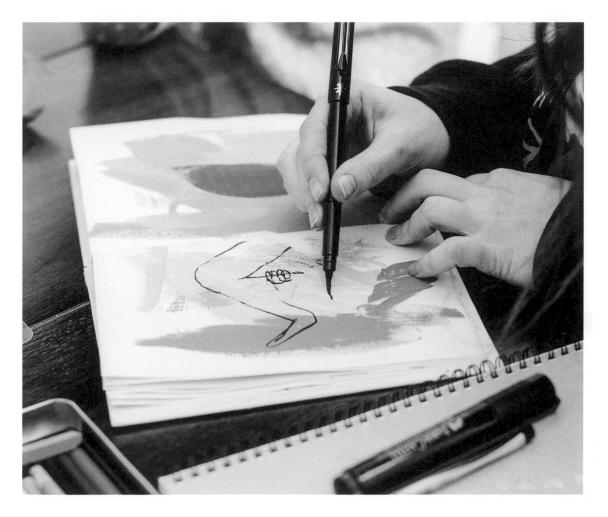

"

I found it really enjoyable to do figure drawing in a more casual setting like this. Drawing friends somehow took the pressure off and I was able to not get too uptight while drawing. I didn't really focus on getting the likeness right, just took the opportunity to use the pose as reference and inspiration for my drawing.

ANA

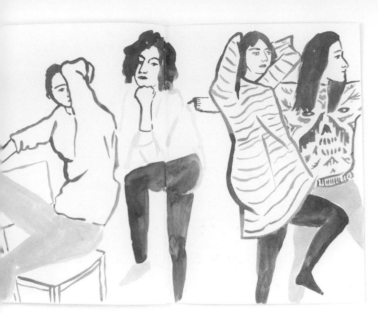

Leah

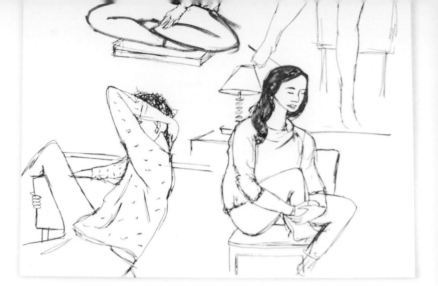

Andrea

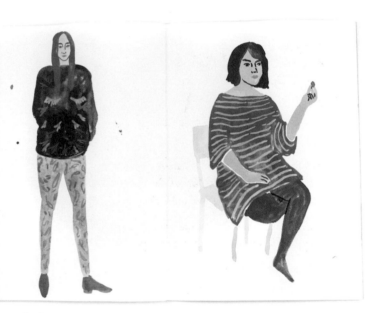

Leah

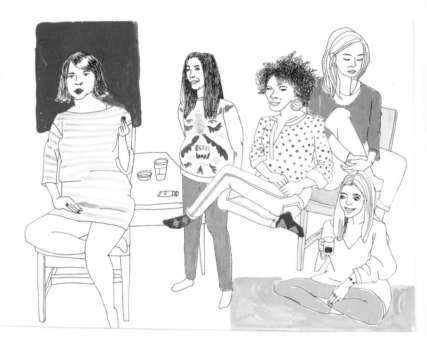

Julia

Ana

Ana

Strike a Pose *Ladies Drawing Night*

It's an interesting twist when we became the subject of a drawing. This is one of the few times in our lives when a group of people looks at us and isn't potentially judging us. They are looking at our form, the shapes we are composed of, and how they can best represent us. Being on the other side of the page connected us with the drawing process in another way and gave us a sense of comfort in our own skin.

HERE'S HOW YOU CAN DO IT

- Take turns posing for each other. As the model, try not to move at all. Pick positions that you know you will be able to hold for a long time without having to adjust.

- Time your poses. Start with shorter poses and gradually increase them. We did ten-minute and fifteen-minute poses, but you can also try quick poses (three to five minutes) and longer ones (twenty minutes).

- Study your subject thoroughly. Try to capture an essence of a person and don't worry about it not *looking like* the subject.

- Watch the time. It's limited, so make sure you work as quickly as necessary to finish your piece.

- Be aware of the composition of your page. Think about getting the figure to fit well in the space of your paper. If you are drawing the entire body, try not to miscalculate and cut off the top of the head or the feet. Visualize where your drawing will fit before you start drawing.

- Get experimental. Try overlapping your drawings. Use your mistakes and let body parts appear disproportionate. Add color and texture after the timer runs out.

HERE'S WHAT WE USED

Ana Acryla gouache, Pentel brush pen, Faber-Castell pens, china marker, colored pencils, sketchbook

Andrea Sharpie Brush Marker, Uni-ball Fine Pen, Faber-Castell Pitt Pen

Leah Winsor & Newton gouache, Winsor & Newton Series 7 watercolor brush, Kunst & Papier soft cover sketchbook

Julia Uni-ball pen, Winsor & Newton gouache, heavyweight watercolor paper

Rachael Sumi ink, sumi brushes, various papers

Rachael

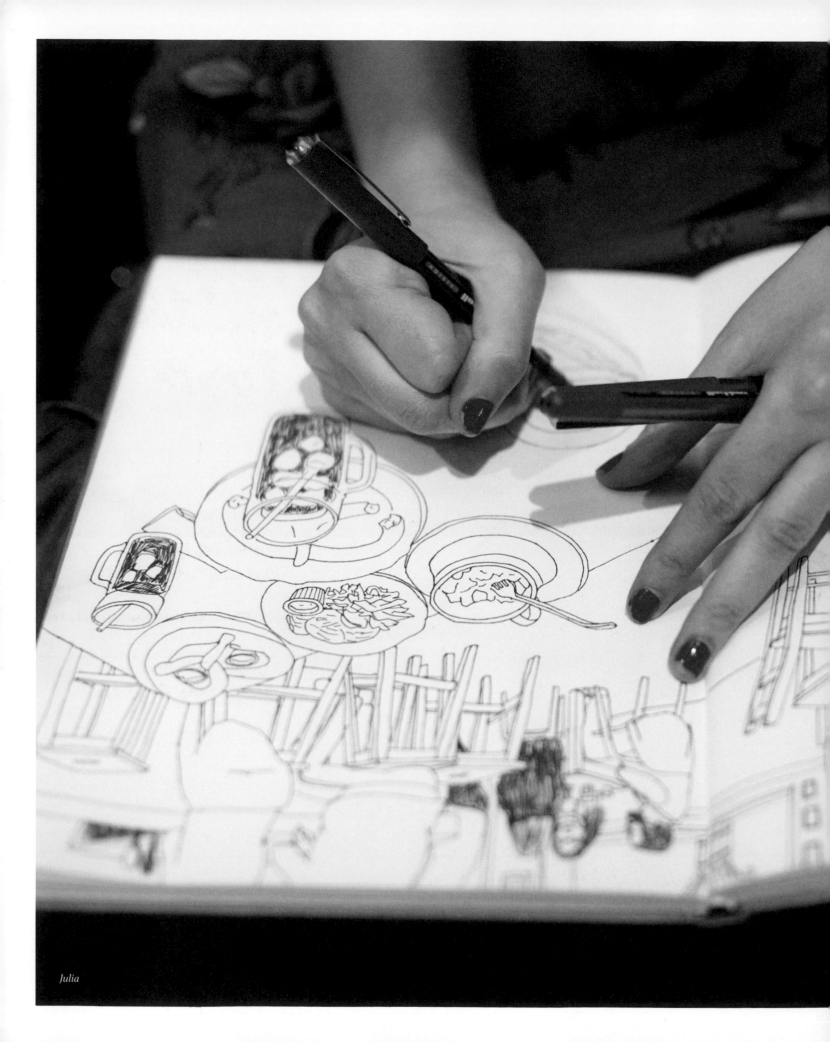

Julia

Night on the Town

with Nora Krug and
Danielle Kroll

where A biergarten in
Fort Greene, Brooklyn

Whether we're working on projects or drawing just for fun, we usually do it in our homes, offices, and studios, surrounded by familiar faces and things. Getting out, and away from the everyday, is an opportunity to draw from life and find unexpected subjects to record with pen and paper.

Ladies Drawing Night is usually held in studios and apartments, and we were ready for a change of scene. We gathered at a local restaurant and bar to draw over drinks and snacks, and we invited Brooklyn-based illustrators Danielle Kroll and Nora Krug to join us there.

After graduating from the Tyler School of Art, **DANIELLE** moved to Philadelphia to work for Anthropologie. There she designed invitations and other printed material for several years before moving to New York to pursue a career as a freelance illustrator. Danielle still names Anthropologie among her clients and also designs stationery for Kate Spade, illustrates books, and works on a plethora of other freelance projects.

NORA is originally from Germany and has lived in New York for the past twelve years. Her interests span a huge breadth—she's studied music, set design, communication design, and documentary film. After studying at the Liverpool Institute for Performing Arts (founded by Paul McCartney), where she majored in Performance Design, she moved to Berlin to study documentary film and illustration and received her MFA in Communication Design. She then moved to New York to study in the MFA program at the School of Visual Arts. She has covered a lot of ground in her illustration work since then. Currently, she teaches full-time in the illustration program at Parsons School of Design.

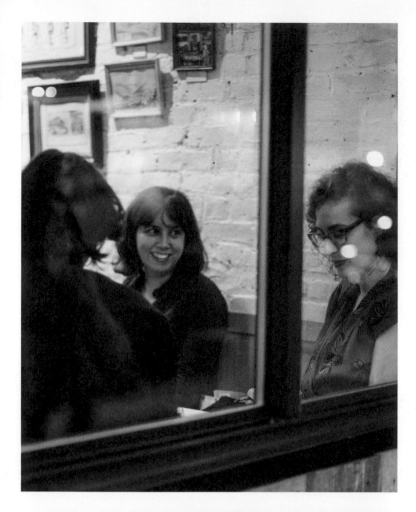

THE BAR IS TEEMING with people and only one dark corner is free. We sit down around a long bench and unload our supplies. Leah traveled lightly, with just a small sketchbook, a travel watercolor brush pen, and a small palette. "I wish I had a bigger sketchbook or more brushes," she says, "but I didn't want to get all my paints out because it gets messy."

Nora is also travel-ready and brought a leather satchel her mother made her with small compartments that fit pens, pencils, and other tools. "Tonight it's very handy because I can roll it up and it can hold twenty pens," she says. "So I brought that and basically included colored pencils and regular pencils, which I often like to work with."

Rachael and Julia skip the paint and ink altogether in favor of pen on paper, and Rachael also experiments with colored pencils. "I don't usually use colored pencils," she says, "but I really like them."

Danielle, on the other hand, brought everything she would usually use to draw with: gouache, palette, brushes, and a stack of paper. "Anytime I go anywhere I always bring my paints and my paper, even if I'm just going to a friend's house. I always have it with me, so I didn't really think about it." She continues, "I feel like I can draw anywhere. I go on a lot of hikes and I always bring my watercolors and brush. When I'm outside I'll notice if there's a pretty tree branch or something and I think, *Oh, I love that, I would love to draw that*, and just sit down and do it."

At first glance, the restaurant looks like any other. There is a bar lined with people on stools and many tables with people clustered around them in chairs. Leah, Rachael, and Julia draw what they see in front of them and get lost in all the details of the crowd. Julia is the most at ease, because she loves drawing in public places. "My favorite is the airport," she said. "I think drawing really relaxes me because I get focused and I start paying attention to so many small details and all I'm thinking about is *what is that, what is that, put it down, mark it*. It's meditative."

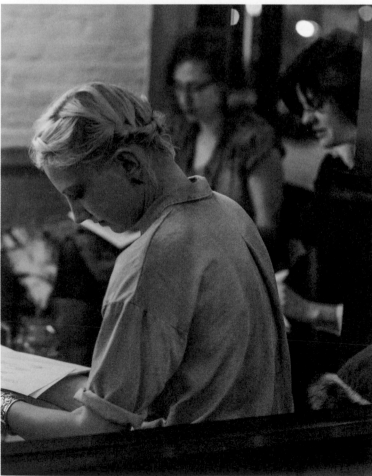

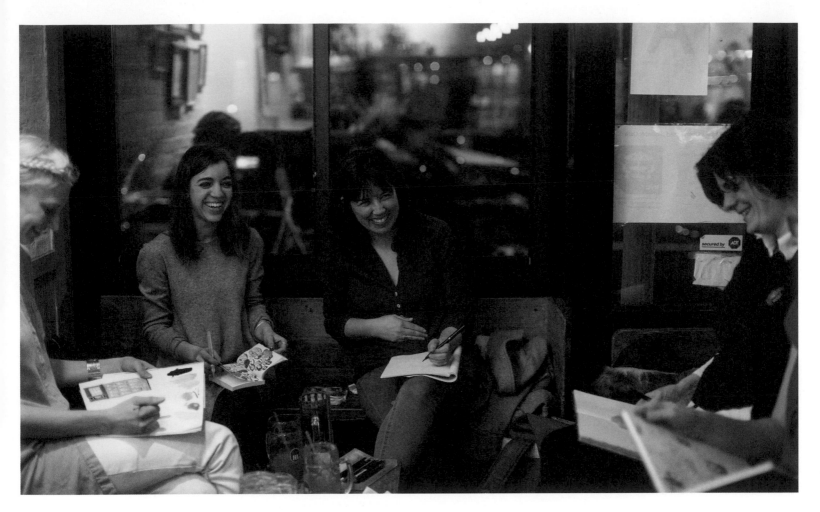

Nora and Danielle look further, finding small details in the room they can pull from for inspiration. "I'm not very good at drawing from life, so my drawings always mutate into some sort of inner world even if I try to draw the outer world," Nora says. "There are etchings of hikers in traditional hiking outfits with old-fashioned backpacks on the wall, so I am inspired to pick up that theme and create my own fantasy around it."

Danielle looks to the decor, noticing a wall of cuckoo clocks no one else has seen. "I've always loved clocks for some reason," she says. "I think they have really interesting forms or shapes, and these cuckoo clocks had a lot of filigree and little details I love to draw."

We eat gigantic pretzels with mustard, we drink Bloody Marys and beer, we chat and laugh and fill page after page with drawings. As we walk home later, we discuss how it felt to be out drawing in a big group.

"I felt fine," says Nora. "I think if we had been sitting more in the center of the restaurant and people would have watched over our shoulders, I would have felt more self-conscious. And also if I had been alone. But drawing in a group, I didn't have any problem."

"We're all doing it together, so what's going to happen?" Julia agrees.

"But also we were more conspicuous, even though we were kind of to the side; we were all drawing, so I think some people noticed," says Leah.

"Yeah," Julia adds, "if you're alone, no one notices you."

"I always feel like when I'm the only one drawing people are judging me for showing off, like *she thinks she's so cool*," Danielle says.

"I could see how other people looking at us would think, *Oh, how Brooklyn*," says Rachael.

"I didn't think about anybody else at all!" Julia laughs. "The guy at the bar knew I was drawing him! We made eye contact various times, but I was like, *Oh well!*"

"

I don't really draw people too often, so I kind of steer away from that. I don't know why; I'm just not really interested in drawing people. I was definitely looking more at what was on the walls and in the background of the crowd.

DANIELLE

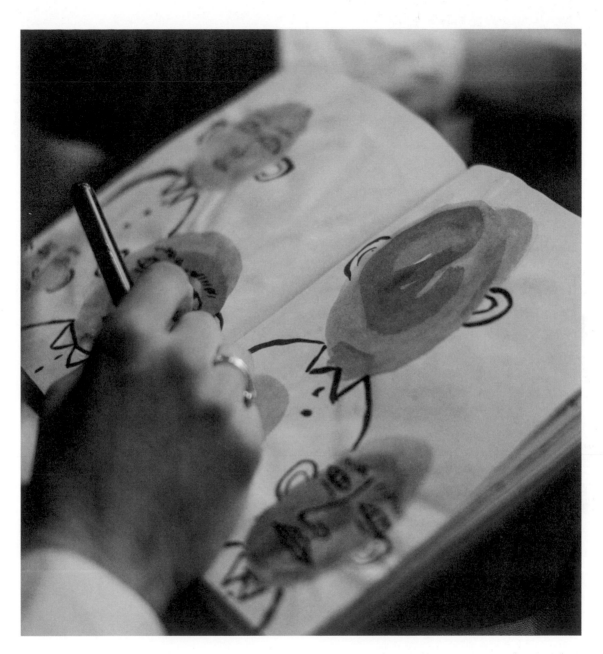

"

I also messed around with some old sketches I had
in there that I added things to.

NORA

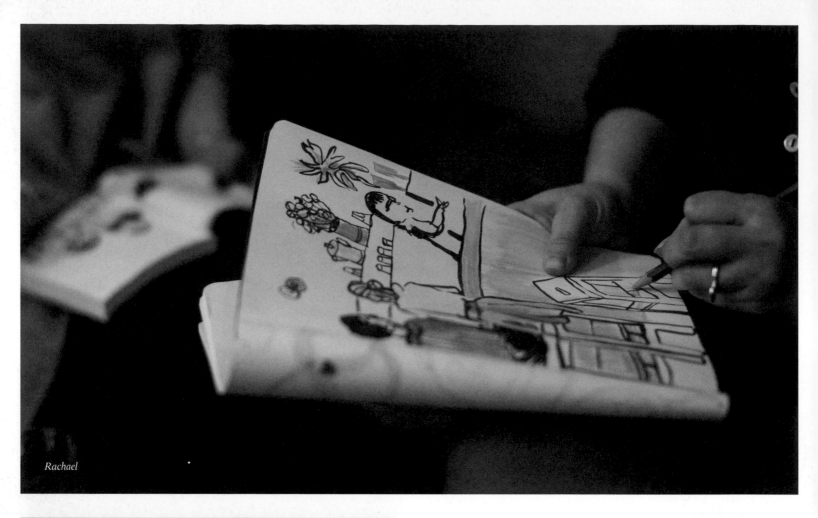

Rachael

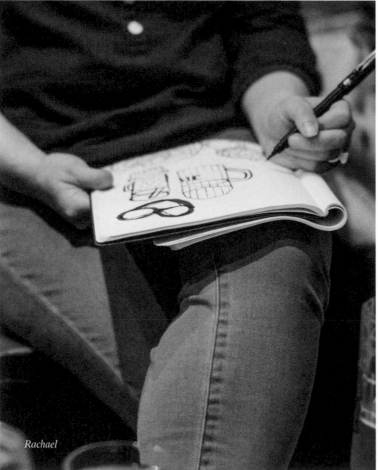

Rachael

> "
>
> My most ideal creative situation is with other people but we're not talking. People I like. It could be strangers, but I prefer friends.
>
> **RACHAEL**

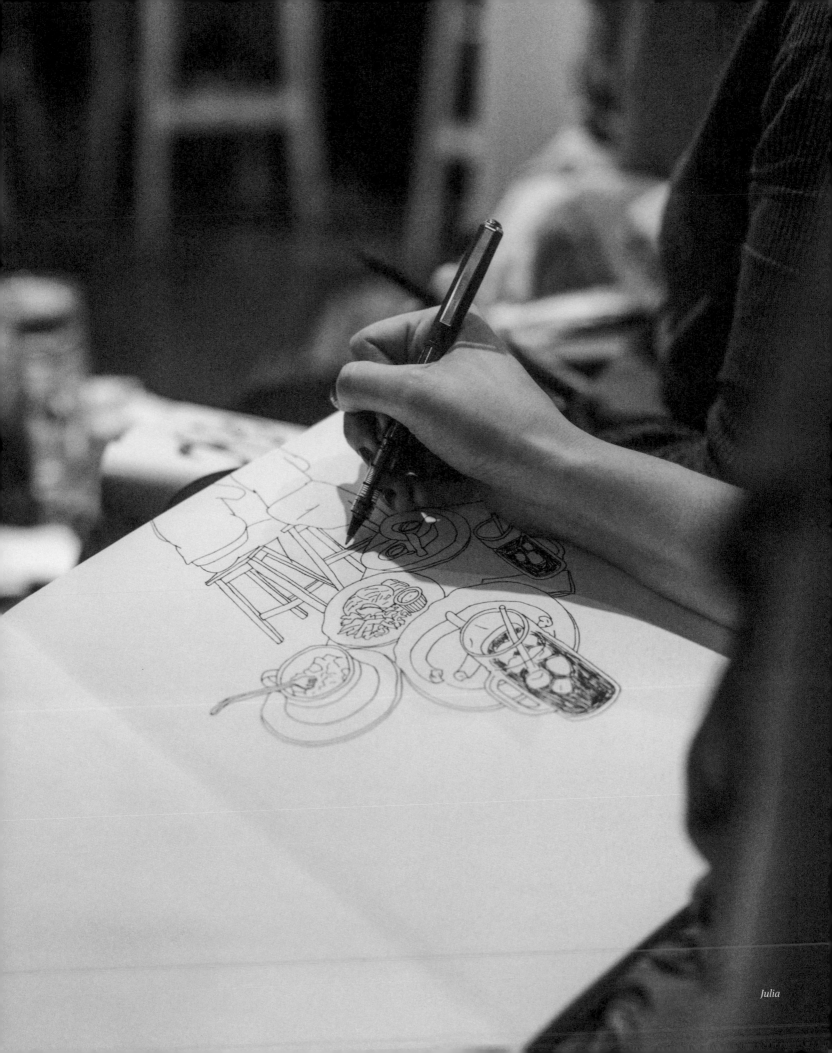

Julia

"

If I'm trying to get some things done for a project
I think it's best to be alone and silent, or with music
on, but if I'm just doodling, I can be anywhere.
It doesn't really matter about the mood or who's
there. It's a habit for me; I've always been a
doodler. In school I always drew in the margins;
I have to be drawing. I feel like it helps me listen.
When I'm drawing I listen better, rather than just
watching someone.

DANIELLE

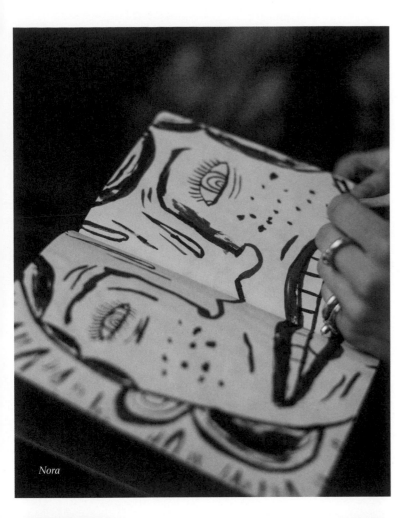

Nora

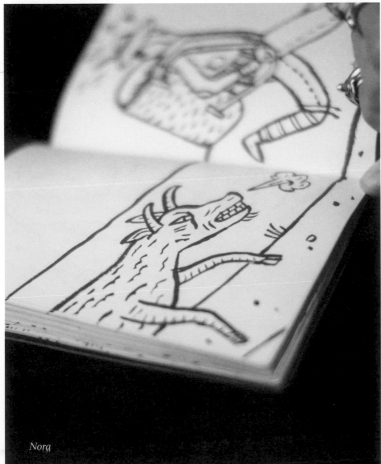

Nora

The medium is about the content, so I often choose the medium based on what I want to say. What I like about the brush pen is it really forces you to confront the medium; you can't make any corrections.

NORA

I don't doodle; I'm not a doodler. I really need a story or a project or a certain framework to get into the act of drawing, because drawing for me has never been about the act of drawing, it's been about communicating, and if I don't really have a clear idea of what I want to say, I don't know how to draw. So usually when I draw I'm involved in a project and I need to focus on the narrative or the purpose of the project and what I want to say.

NORA

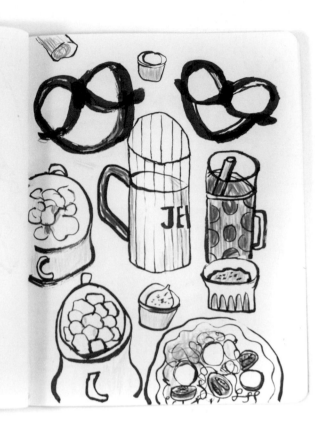

Rachael

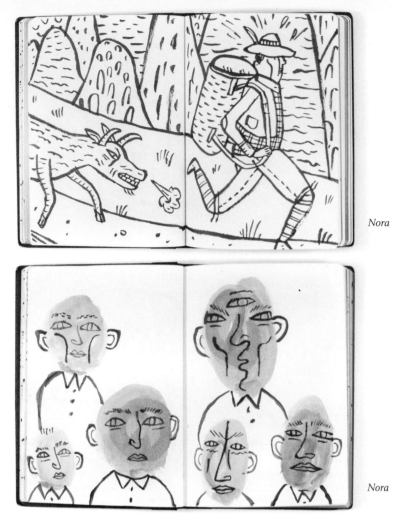

Nora

Nora

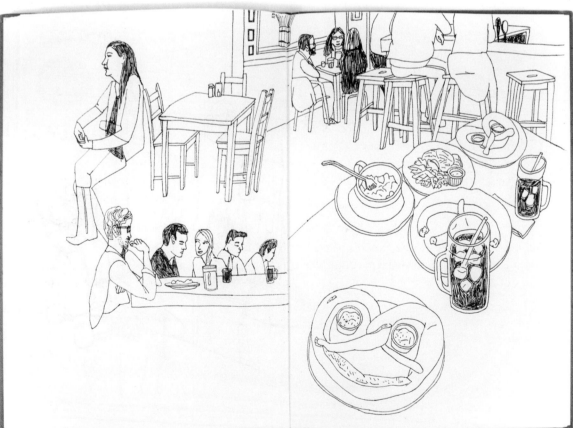

Julia

Night on the Town *Ladies Drawing Night*

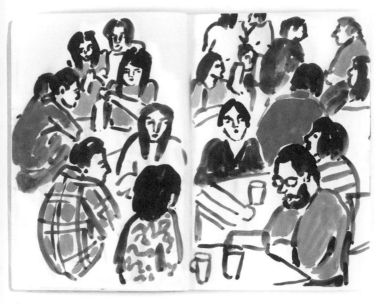

Leah

BLACK FOREST BROOKLYN

Danielle

OUR TAKEAWAY

When we're drawing outside of our studios, we have to realize things won't be perfect—our supplies will need to be limited, we may not get a comfortable lighting situation, people may stare. We need to be flexible and take these conditions as they come. Interesting drawings could result due to working in a public environment.

HERE'S HOW YOU CAN DO IT

- Get out of the house! Restaurants, bars, coffee shops, parks, museums, zoos, pools, beaches, botanical gardens, airports, train stations, subways, waiting rooms, libraries, and any public space you can think of are all good places to draw.

- Consider your supplies. Take only what will fit on your lap and will allow you to easily maneuver.

- Sit, observe, and then draw. Spend at least a few minutes orienting yourself and picking out what you would like to draw.

- If someone approaches you, be polite, and if they don't want you to draw them, always respect their wishes.

HERE'S WHAT WE USED

Danielle Gouache, brushes, paper

Nora Leather-bound sketchbook, Pentel brush pen

Leah Niji waterbrush, small Muji sketchbook, dry leftover gouache palette

Julia New York Central Art Supply sketchbook, Uni-ball pen

Rachael Moleskine soft cover sketchbook, Pentel brush pen, colored pencils

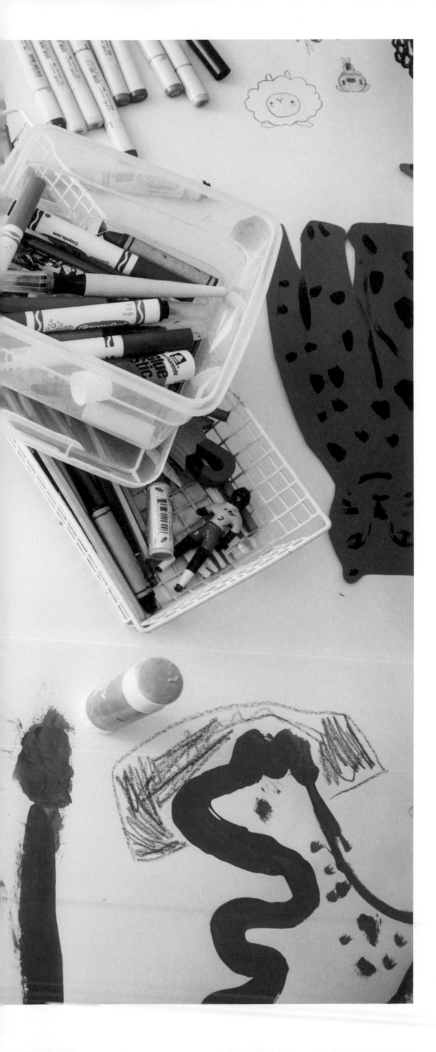

Kidding Around

with Charlie, Max, Anaïs, Colette, and their mothers, Jaime Rugh and Yoon Chang

where Rachael's apartment in Fort Greene, Brooklyn

Children are often uninhibited in their artistic expression. While we had experienced some of that feeling during ink night, we wondered if collaborating with children might build on our sense of creative freedom. As we reached for the crayons and school-grade paintbrushes, we wanted to be imaginative and judgement-free, and to just have fun.

Rachael is a mom of an adorable three-and-a half-year-old, Alex. She had been planning this special afternoon session for a while and was excited to share her experiences helping organize children's art activities with Leah and Julia. "Seeing kids explore materials and mark-making is honestly a joy like no other," Rachael says. "You guys are going to love it!" Rachael invited Jaime Rugh and Yoon Chang, two mothers from creative families, to join us with their children.

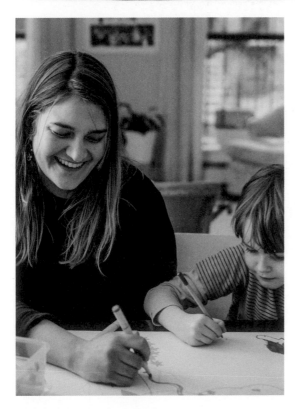

JAIME, the mother of **CHARLIE**, nine and a half, and **MAX**, seven, studied fiber arts at the Maryland Institute College of Art and eventually went into floral design. After living in New York City, her family settled in New Jersey and then decided to homeschool their children with a focus on the arts. "We live a pretty creative, fun life," remarks Jaime.

YOON CHANG, the mother of five-year-old twins **COLETTE AND ANAÏS**, is a fashion designer who teaches fashion illustration to kids from second to fifth grade as well as a fashion thesis course at Parsons School of Design. She's been living in New York for over twenty years and graduated from Parsons herself. Later she worked for fashion label Cynthia Steffe, and then co-owned a label called Whistle & Flute. Yoon has encouraged her daughters to draw and create from the moment they could hold a crayon and they spend a lot of time drawing together.

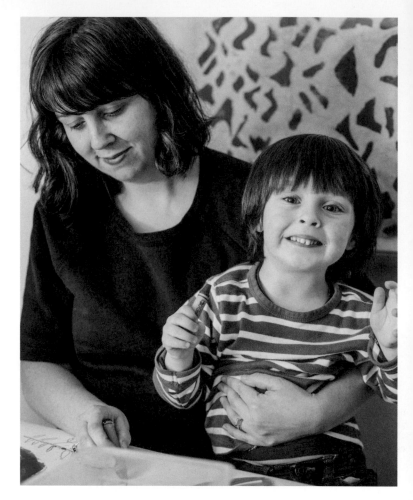

THE KIDS ARRIVE like a volcano of energy. While Alex plays with an old typewriter and sings, twins Colette and Anaïs are shrieking in delight and rolling around on the floor. Charlie is chattering with her brother, Max. Meanwhile, their mothers, Yoon and Jaime, help us lay down heavy butcher paper and put out tempera paint, colored construction paper, markers, crayons, and pencils. We had prepped the moms well ahead of time with our theme, a fantasy zoo, so that the kids had time to get excited in advance.

There's a reason we invited these moms and their kids: They are from creative families. Charlie has been into art from a very young age. She has her own studio set up with plenty of high-quality art supplies. "We teach a lot about just doing it, making mistakes, and letting things happen. We also study artists and then do artwork inspired by them. Max has never really been attracted to drawing. Max is strong at math and patterns and figuring out how things work."

Yoon, the mother of Colette and Anaïs, draws often with her daughters. She says, "They are twins, but they are completely different in terms of style. When it comes to drawing, Colette tends to be all about proportion and realism, while Anaïs likes to explore the fantasy side."

Once we are ready to settle in, we gather the kids and moms around the dining room table and review the theme of a fantasy zoo. We toss around names of animals to get the kids thinking, but they have already picked up brushes and markers and are getting busy. "I'm going to make a snake!" proclaims Colette.

"I need some yellow, I need some red!" The requests and compliments fly. Materials are traded across the table. Julia asks Charlie what her favorite thing to draw is.

"Eyes," she answers without hesitation.

"Just eyes?" asks Julia.

"No faces, just eyes," answers Charlie.

Yoon encourages and suggests ideas to Colete and Anaïs, and they also have ideas of their own.

"Mama, I want to make a tiger," pleads Colette.

"I think that's a great idea."

"But I don't know how to make one."

"Well, use your imagination. What does a tiger have?"

"Ears . . . and a face!"

Alex is more of an art director. Leah asks him what she should draw.

"Umm, a lobster!"

"What color should my lobster be?"

"Umm, orange!"

"I'm liking your raccoon a lot," Jaime says to Max.

"Well," he answers, "I'm going to paint the stripes last. I'm going to draw it in gray. Or with a black pencil."

Charlie chimes in. "Oh, I love your raccoon so much, it's the best thing in the whole world."

Max looks at his sister and beams. "Want to see how I make my stripes? I just do this. I just leave a

little line in the middle, and then I do it."

When we decide to take a break for lunch, Jaime observes, "I'm just getting into it, I kind of don't want to stop."

Max says, "I don't want to stop either."

After we eat some lunch, we all rotate chairs, except Max, who wants to finish up his raccoon. Everyone starts building and adding to each other's drawings. Colored paper is ripped and glued.

Julia encourages everyone along. "If a bear needs a hat, or if a peacock wants to go swimming, you can do that."

"Hey, Anaïs, want to draw some polka dots on my hat?" asks Yoon.

"Red polka dots? Okay!" answers Anaïs with a smile.

Leah, Julia, and Rachael all find themselves drawing in sloppy, flat, primitive, happy shapes, reverting back to the way they would have drawn as kids.

Julia surveys the drawing. "There's too much white space over here! Let's fill it in."

The energy, enthusiasm, and delight of the kids is infectious as we all scurry around the paper, cramming the last spaces with color. When almost every last inch is covered, we gather to admire our masterpiece. Charlie notes "I love all the diversity on the paper." The kids keep drawing as we all talk and recap. A school of ducks appears on the drawing at the last minute. As everyone puts on their coats, we brainstorm what the drawing could be made into: "A lamp! Leggings! Wallpaper! A couch! A crop top!"

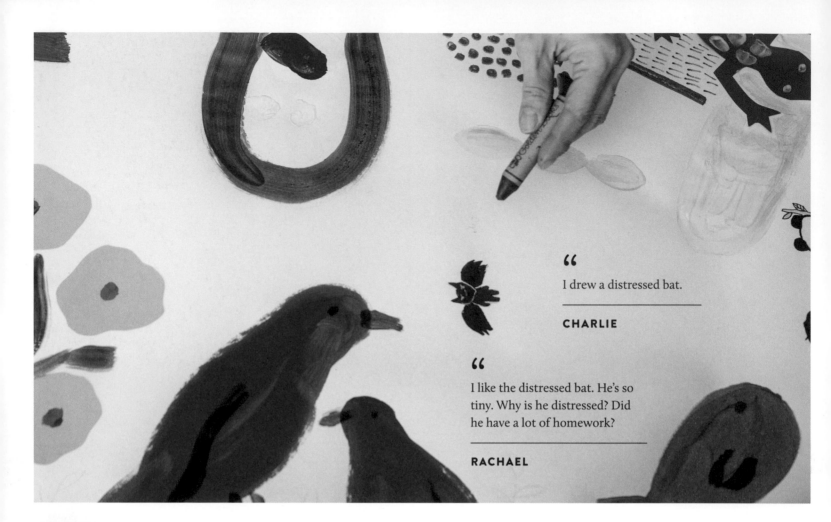

> I drew a distressed bat.

CHARLIE

> I like the distressed bat. He's so tiny. Why is he distressed? Did he have a lot of homework?

RACHAEL

> You make a weird, amorphous shape, and then I'll make an animal out of it.

JULIA

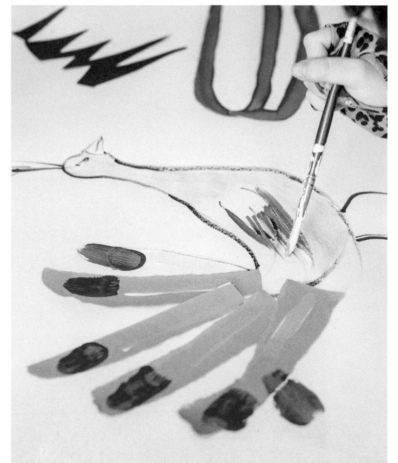

"
I want to make the giraffe all blue.

COLETTE

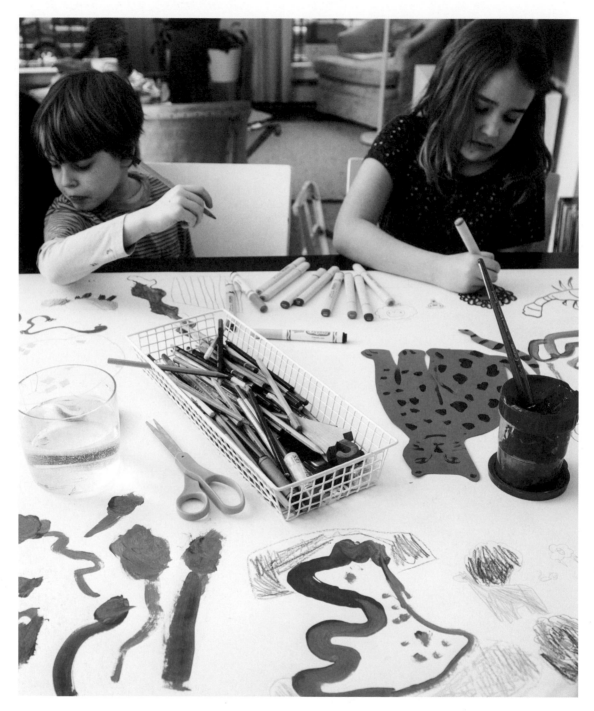

"

I love the idea of a panda on bamboo. Maybe I'll add some bamboo to my drawing.

CHARLIE

Kidding Around *Ladies Drawing Night*

"
I'm liking your raccoon a lot.

JAMIE

"
Want to see how I make my stripes? I just do this. I just leave a little line in the middle, and then I do it.

MAX

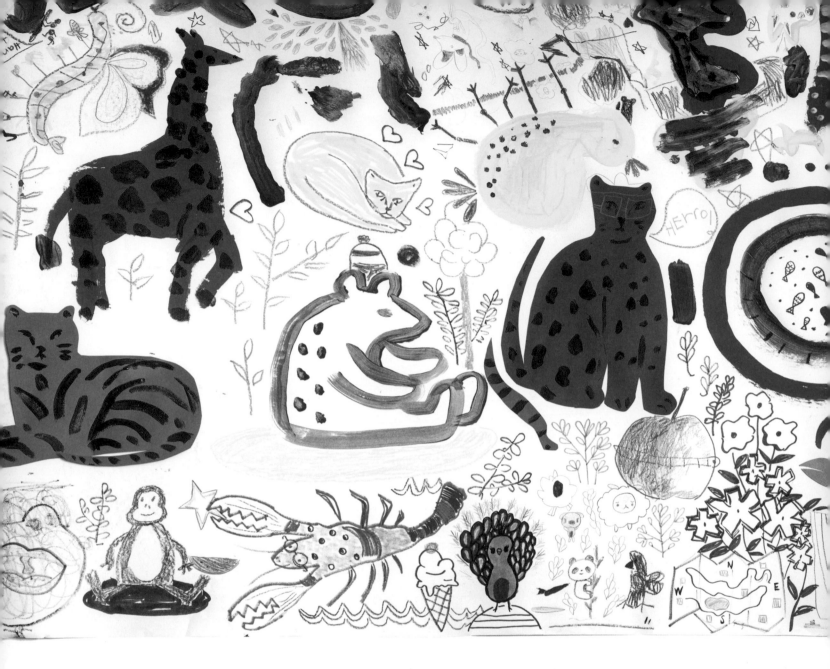

OUR TAKEAWAY

There are no adults or children at the table, just artists. When we are all drawing together, we feel a sense of equality. The natural feeling of teacher and student vanish. Instead, we just draw together, cooperating and encouraging each other along.

HERE'S WHAT WE USED

Large roll of heavyweight drawing paper, Melissa & Doug poster paints, Melissa & Doug paint cups with brush holders and snap-on storage lids, crayons, colored pencils, various brushes, markers, scissors, glue, paper towels

HERE'S HOW YOU CAN DO IT

- We suggest including kids ages five and up for this activity, but use your own judgment. It's a bit easier to draw with older kids who have developed longer attention spans.

- Pick a theme. We decided on fantasy zoo so we could draw crazy animals. It helped that the moms talked to their kids about the theme beforehand, to get them excited.

- Get a large roll of butcher or drawing paper. We suggest something a bit heavyweight so that it doesn't rip or buckle.

- Gather together materials before the kids arrive, if possible.

- Try to encourage rather than direct the kids. Listen to their suggestions as well.

- After a while, take a snack break and then rotate seats. Add on to each other's creations.

- Look for gaps in the image and fill them in!

Thank you so much for joining us on our drawing nights. Keep in touch and follow more of our work on our websites:

JULIA ROTHMAN
juliarothman.com

LEAH GOREN
leahgoren.com

RACHAEL COLE
rachaelcole.net

Find out more about our talented guests:

JOANA AVILLEZ
joanaavillez.com

NORA KRUG
nora-krug.com

JAIME RUGH
(with Max and Charlie)
jaimerugh.com

ANA BENAROYA
anabenaroya.com

RACHEL LEVIT
rachellevit.com

LAUREN TAMAKI
laurentamaki.com

KAYE BLEGVAD
kayeblegvad.com

LIZ LIBRÉ
lindaandharriett.com

ELLEN VAN DUSEN
dusendusen.com

YOON CHANG
(with Anaïs and Colette)
fashion123ny.com

MARY KATE MCDEVITT
marykatemcdevitt.com

JING WEI
jingweistudio.com

SAMANTHA HAHN
samanthahahn.com

LOTTA NIEMINEN
lottanieminen.com

ELLEN WEINSTEIN
ellenweinstein.com

AYA KAKEDA
ayakakeda.com

ANDREA PIPPINS
andreapippins.com

PING ZHU
pingszoo.com

DANIELLE KROLL
hellodaniellekroll.com

MONICA RAMOS
monramos.com

ACKNOWLEDGMENTS

This book was a collaboration with many other women behind the scenes.

Each night we were also accompanied by the lovely **KATE EDWARDS**, a photographer from Brooklyn who inconspicuously snapped photographs of us as we worked. Kate's presence added to the dynamic. She was always cheering us on, excited to watch the drawings develop. We were so glad to have her work with us, capturing the evenings beautifully. Her work can be seen in fashion magazines from around the world and in ad campaigns and catalogs.

kateedwardsphotography.com

Our designer, **JENNY VOLVOVSKI**, took all of our content—the writing, photographs, instructions, and quotes—from the ten Ladies Drawing Nights and found a way to lay it out cleanly and gracefully. Jenny and Julia work together often, along with Matt Lamothe, as ALSO, a company the three of them formed after graduating together from the Rhode Island School of Design. Jenny does most of the design for the company and has created book covers, packaging, and websites for a wide range of clients. In fact, she enjoys designing book covers so much that she started her own blog, *From Cover to Cover*, where she redesigns covers of books that she reads. We are fortunate to have been able to collaborate with her again.

also-online.com
from-cover-to-cover.com

The team at Chronicle Books was incredibly supportive of our project. We feel honored to work with such a talented group who seems to value the same things we do. We worked with art editor **BRIDGET WATSON PAYNE**, who cheered us on every step of the way. She also guided us through the editing process smoothly and had many thoughtful suggestions. Bridget has been an editor of art books for more than a decade and in that time she's collaborated with hundreds of authors and artists to make their book ideas a beautiful reality.

chroniclebooks.com
pippascabinet.blogspot.com

Lastly, we just want to say thanks to our significant others, Mars, Dylan, and Santtu, who put up with ladies kicking them out of their homes to make inky messes. Thanks to Eron Hare for his assistance as well! And to all the ladies who have joined us at drawing night, we will keep the tradition going, so we'll be in touch. xoxo